A THOUSAND YEARS OF THE BIBLE

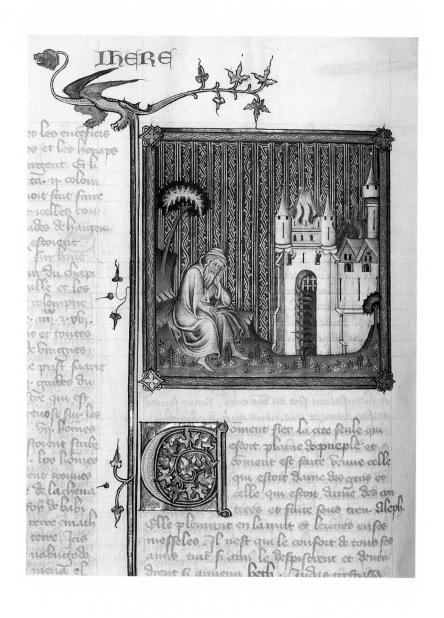

19. Petrus Comestor, *Bible Historiale*, translated by Guiart
des Moulins. Paris, circa 1375. Ms. 1, vol. 2, fol. 86v:
Jeremiah Before Jerusalem in Flames.

A THOUSAND YEARS OF THE BIBLE

AN EXHIBITION OF

MANUSCRIPTS

FROM

THE J. PAUL GETTY MUSEUM

MALIBU

AND

PRINTED BOOKS

FROM

THE DEPARTMENT OF SPECIAL COLLECTIONS

UNIVERSITY RESEARCH LIBRARY, UCLA

Malibu

The J. Paul Getty Museum

Los Angeles

University of California

1991

Table of Contents

FOREWORD

In the years since Henry Huntington acquired his Gutenberg Bible, southern California has become a center for studying the arts of the book. Each of the region's libraries, universities, and museums can boast individual treasures, but when these resources are taken together, the results are remarkable.

The extent to which the collections of the J. Paul Getty Museum and UCLA's research libraries complement each other can be judged in *A Thousand Years of the Bible*. The manuscripts at the Museum offer insights into the variety of forms the Bible took during the Middle Ages and the Renaissance, and the magnificence of the decoration it inspired. Printed editions from the Department of Special Collections at the UCLA Research Library continue this story, where volumes from more than a dozen countries, and in twenty different languages, reveal the impact of the printing press as much as they reflect the ecumenical character of religion.

But as is often the case, the whole is greater than the sum of its parts. This joint exhibition allows us to consider the Museum's biblical manuscripts and UCLA's printed books together. Not only can we appreciate each volume as an individual achievement, we can – thanks to this collaboration – consider one of the most significant traditions in western culture as a whole.

John Walsh
Director
J. Paul Getty Museum

Gloria Werner
University Librarian
UCLA

BIBLE COLLECTIONS IN LOS ANGELES

John Bidwell

Reference Librarian

William Andrews Clark Memorial Library

The Bible occupies a special place in our world of books, having helped to create the book in the form that we now recognize and having communicated in this form some of the basic traits of western culture. Few books can be read in so many different ways: as a code of law, a message of hope, a treasury of wisdom, a record of past events, and a guide for future conduct. The Bible consoles, instructs, and inspires. Few books have been read so intensively, not once or twice but many times over, either silently in moments of private meditation or aloud in gatherings of friends and family. Scribes labored hard to copy this text and interpret it. Working in monastic scriptoria and in the trading centers of international commerce, they developed new techniques to distribute and embellish manuscripts of the scriptures. Large and expensive, the Bible posed a formidable challenge to those who wished to make it readily available; nevertheless, it was the first major book to be printed in the West and at times the most often reprinted. Publishers have developed new editions for different markets, churches have sponsored approved versions for the faithful, learned editors have reexamined and corrected the text, and translators have disseminated Holy Writ in a multitude of languages. A scholar cannot expect to understand changes in language, the growth of literacy, or the history of religion in many countries without first consulting the bibliography of the Bible.

Fully aware of its importance, collectors, bibliographers, and librarians have sought manuscripts and early printed editions for their beauty, textual authority, and historical relevance. Rare and valuable editions filled the shelves of some of America's earliest collectors, most notably George Brinley and James Lenox. The American Bible Society has stocked its library in New York with cheap reprints and obscure versions, many unrecorded elsewhere. Research libraries and theological

seminaries across the country have also built strong collections for various purposes.

Both collectors and librarians in Southern California have shared this fascination with the Book of Books. Some have been content with a few prime examples; others attempted to assemble large collections suitable for research; some built and endowed libraries to preserve their holdings; others allowed their books to be dispersed. Early Bibles came to Los Angeles by many different routes and in diverse circumstances – which might be particularly appropriate to review here, if ever so briefly, on the occasion of this collaborative exhibition.

Antiquarian booksellers have often been the conduit that channeled Bibles to this part of the country. Los Angeles collectors made some of their most spectacular acquisitions through booksellers on the East Coast or abroad, who either bid for their southland customers at auction or kept in their own stock a tempting selection to be offered in quotes or catalogues. While buying many of their greater treasures from out of state, collectors also frequented such enterprising local dealers as Alice Millard, Ernest Dawson, and Jacob Zeitlin. Alice Millard supplied some of this city's most renowned private libraries while building a personal collection that, in 1933, included a thirteenth-century manuscript of the Bible. In 1929 Dawson's Book Shop sold another thirteenth-century manuscript to John I. Perkins, a regular customer for early books and modern fine printing. Indirectly, Dawson's Book Shop has contributed to this exhibit an unusual polyglot edition of the Lord's Prayer (cat. no. 61). The bibliographer Robert Ernest Cowan purchased this early Mexican imprint at Dawson's in 1931 to add to his superb collection of western history and Californiana, which he sold to UCLA in 1936. The firm of Zeitlin & Ver Brugge also helped to make this exhibit possible when, in 1983, it joined with the New York

4

dealer H. P. Kraus to negotiate the sale of the celebrated Ludwig collection of medieval and Renaissance manuscripts to the J. Paul Getty Museum. Some of the extraordinary Bibles of the Ludwig collection are admirably described below by Ranee Katzenstein, Assistant Curator of Manuscripts at the J. Paul Getty Museum.

Like the Getty Museum, the Huntington Library in San Marino preserves a rich array of Bibles to be studied as texts, historical artifacts, and works of art. Railroads and real estate furnished Henry E. Huntington with the means to build one of the greatest rare book libraries in the world, formally established in 1919. The American public first learned about his magnificent plans in 1911, when he purchased Robert Hoe's Gutenberg Bible on vellum at the record-setting price of fifty thousand dollars. Until then nobody had ever paid such a fabulous sum for a single book. Although Huntington also paid handsomely for early English literature at the Hoe sale, it was this round figure that caught the public's imagination and prompted it to consider what Huntington should achieve with his library of rarities, what value should be placed on old books, and why the Gutenberg Bible should be valued most of all.

For all of its mystique, the Gutenberg Bible should not be allowed to overshadow the manuscripts, other fifteenth-century editions, and early English editions at the Huntington Library. It certainly cannot rival the great age of the venerable Gundulf Bible, a manuscript written in England in the latter eleventh century and known to have been in the Rochester cathedral library as early as circa 1130. A thirteenth-century inscription states that it once belonged to Gundulf, a bishop of Rochester who lived from 1077 to 1108. Among other manuscripts, the Huntington has more than a dozen thirteenth-century Bibles noteworthy for their small size and ingenious design. Together they reveal a new tendency in manuscript production, a desire

5

to furnish the Bible in an economical format suitable for personal convenience.

As of 1937 the Huntington Library contained around eighty fifteenth-century editions of the Bible, mostly in Latin but also in German and Italian. At few other libraries could one muster such a quantity of early editions, an important resource for the study of the printing trade in its infancy and an unparalleled opportunity to compare how the first printers coped with this formidable text. Budgetary constraints and other priorities slackened the pace of Huntington's rare book acquisitions during the 1930s and 1940s. In 1943 the Library informed one antiquarian bookseller that it had quite enough of early Bibles, thank you, and would no longer buy in this area, nor would it buy prayer books or other texts already well represented in the collection. Happily, it has reconsidered this decision and continues to build on strength. It has dozens of early English Bibles, including the Coverdale Bible of 1535, various editions of the Great Bible, the Geneva version of 1560, the Roman Catholic version printed at Douai in 1609-1610, and of course the Authorized Version in English, first printed in 1611. All these and more are accessible to scholars in America and abroad through the Library's cataloging, its published guides to its manuscripts, and its invaluable participation in compiling union lists of early printing and English imprints.

Other Los Angeles libraries have substantial Bible holdings that deserve to be better known. The Ostrow Library at the University of Judaism is just beginning to inventory a wonderfully eclectic collection of five thousand volumes donated a few years ago by Dr. Benjamin Maslan of Seattle. Maslan, an impassioned reader of antiquarian booksellers' catalogues, never had to read beyond the letter B. And he never had to spend more than £100 or £200 at a time, for he cast a wide net in his Bible collecting during the 1960s, when many obscure

editions and defective copies were priced to move. He acquired Bibles published in any country, at any date, and in any language – including Syriac, Tagalog, Chinese, and Cherokee. He obtained his first edition of the Geneva Bible at the bargain price of £50, having decided that he could make do with a photocopy of its title page. Although he could never afford even a defective copy of the first Bible printed in America, Eliot's Indian Bible of 1661-1663, he could compensate with two copies of the next great American Bible, the first in a European language and a tour de force of colonial bookmaking, the Christopher Saur Bible printed in Germantown, Pennsylvania in 1743. Both copies lack preliminary leaves, but are accompanied by the second Bible of the Saur family (1763) and the third (1776). The Maslan Collection is a unique and important resource for the study of the Bible precisely because of Maslan's wholesale disregard of imperfections and condition: his goal was not to collect books but to possess every possible manifestation of the scriptures. The broad scope of his collection sets it apart from most rare book libraries, which all too often have neglected the great extent and variety of Bible production to collect isolated highspots. Who knows what discoveries are there to be made in the Maslan Collection? The University of Judaism will be sure to increase our store of knowledge about the Bible if given adequate support to identify and preserve its early editions. No doubt some will turn out to have been hitherto unavailable in America, and a few as yet unrecorded in the standard bibliographies.

Most Bibles made their way into Los Angeles libraries one or two at a time, not in one massive gift. John I. Perkins donated his manuscript Bible to the Denison Library of Scripps College at Claremont, not far from the Claremont Colleges' Honnold Library where two similar manuscripts can be examined along with other important early books presented by Dr. Egerton L.

Crispin, a Los Angeles physician. UCLA and the University of Southern California have likewise benefited from the generosity of local collectors to build significant resources in this field.

UCLA's holdings have come from so many different sources that it would be impossible to survey them all here. Instead, I will take three examples from this exhibit to suggest the wide variety of collections the University has acquired during the last few decades, and the wide appeal of the Bible to the Southern Californians who formed those collections.

Edward A. Dickson, newspaperman, financier, and Regent of the University from 1913 to 1956, took a special interest in the books and libraries of the Los Angeles campus. He played an important role in the establishment of the William Andrews Clark Memorial Library, bequeathed to the University in 1934. He admired fine typography and even collected a few early books of his own, such as a Cologne Chronicle (1499) now at the Department of Special Collections. He went so far as to persuade the University of California Press to commission its own proprietary typeface, designed by Frederic W. Goudy. This endeavor excited so much enthusiasm in the University that Goudy was awarded an honorary degree. Dickson proposed that the new typeface should be inaugurated with a publication to mark the five hundredth anniversary of Gutenberg's invention of movable type. "What an opportunity," Dickson wrote the Press. "Celebrate the 500th anniversary of that event by having Goudy cut a type for the University of California, to be first used in 1940 in the printing of an appropriate memorial." In due course, University of California Old Style made a striking debut in Goudy's *Typologia: Studies in Type Design & Type Making* (Berkeley and Los Angeles, 1940).

Dickson contemplated an even more ambitious memorial of Gutenberg a dozen years later, when UCLA's University

Librarian Lawrence Clark Powell approached him with a novel scheme to finance a spectacular library acquisition. Powell had learned that Scribner's bookstore in New York had obtained the Shuckburgh copy of the Gutenberg Bible and that David Randall, head of the rare book department at Scribner's, was so eager to find a customer that he would send it to UCLA – on approval! Randall dispatched the Bible by air express and an armored car to the Westwood campus, where Powell entrusted it to a vault in the University Library. The sight of the Bible on Powell's desk fired the imagination of Regent Dickson, who agreed to submit a special appropriation bill for the State Legislature to meet Scribner's purchase price, somewhere between $150,000 and $200,000. Powell and Dickson plotted their strategy carefully. The Legislature would buy the Shuckburgh copy not for Los Angeles or Berkeley but for California, where every year it would parade from one library to the next with ceremonial stops in between to give everybody a glimpse of the Bible in all its glory. The University would lobby vigorously for the bill by enlisting the support of the press, concerned citizens, experts on early printing, and the various libraries that would share this moving monument of printing. It was a glamorous idea, a magnificent plan, but difficult to execute promptly. Unfortunately Randall needed a customer so badly that he could not wait until the next session of the Legislature and so sent the Shuckburgh copy elsewhere on approval and finally sold it to Arthur A. Houghton, Jr. Although Dickson failed to procure a copy of the Gutenberg Bible, he was able to donate a single leaf (cat. no. 21), one of three Gutenberg leaves at UCLA.

While Dickson welcomed publicity, and was prepared to use it for bookish ends, another UCLA donor avoided attention so successfully that his benefactions came as a complete surprise to the University. Walter O. Schneider built a private library

9

remarkable for its privacy. Born in Germany, he immigrated to Los Angeles in 1915 and found employment in the Los Angeles Country Club, where he lived – in the same room – for forty-seven of his sixty-seven years. That room he filled with il-lustrated books, fine printing, artwork of Frans Masereel and Eric Gill, first editions of Thomas Hardy, and the Cranach Press *Song of Solomon* exhibited here (cat. no. 67). When his five-thousand volume collection exceeded the space available in his lodgings, he carefully wrapped and catalogued the over-flow and sent it to the warehouse of a local storage company. He appears to have spent his modest salary on nothing but music, art, and books – all of the finest quality and in the best condition. He visited the bookstores of Los Angeles and joined the Friends of the UCLA Library, without, however, divulging the nature and extent of his collection, or his intention to present it to the University. To this day, we do not know why Schneider favored UCLA in his will. We can only speculate that he must have learned about the UCLA Library through the Friends and decided that his life's work would be appreciated there.

Schneider was probably less interested in the text of this *Song of Solomon* than its illustrations by Gill and its typography by a distinguished German private press. Likewise, May and George Shiers obtained their *Curious Hieroglyphick Bible* (cat. no. 53) not to puzzle over the scriptures but to explore the history of children's education. Residents of Santa Barbara, Mr. and Mrs. Shiers assembled a library of about a thousand early English children's books, especially strong in the period 1780-1830. Although not collected as Bibles, these two texts gain new significance as Biblical literature now that the Schneider and Shiers collections have joined related collections at UCLA. They will remain in place for the students and scholars of the future, ready to be reinterpreted in the light of new knowledge.

A destiny less secure awaited the Bibles owned by Mrs. Milton Getz, one of Los Angeles's first woman collectors. Timid, nearsighted, less than fashionably dressed, Mrs. Getz never revealed the ample resources she inherited from the founder of the Union Bank except to indulge a passion for literature and fine books. Jake Zeitlin recalled that she carried wads of money inside a bell-shaped hat. Diffidently she approached the counters of several Los Angeles bookstores to buy literary autographs, modern fine printing, incunabula, an archive of Ambrose Bierce, and a wide assortment of early manuscripts. She owned at least three manuscript Bibles dating from the thirteenth to the fifteenth century, two with illuminated borders and initials. Unfortunately her entire collection was dispersed at auction in 1936, apparently because the family fortune took a turn for the worse during the Depression.

Estelle Doheny was without doubt Los Angeles's greatest woman collector and its most zealous collector of Bibles. Sadly her books were also dispersed at auction, even though she had established a library for them in the one place where they were most likely to be appreciated, a theological seminary. Mrs. Doheny also deserves the honor of being one of the most generous donors to the cultural institutions of Los Angeles. She helped to build the Doheny Library at the University of Southern California. She supported the Archdiocese of Los Angeles so munificently that she was awarded the title of Papal Countess in 1939. She gave away several sets of the Complutensian Polyglot Bible as well as fifteen copies of the *Book of Kells* in facsimile. But her most precious rare books and manuscripts went to the Archdiocese of Los Angeles for a seminary it was building in Camarillo, where she founded in 1940 the Edward Laurence Doheny Memorial Library in memory of her late husband.

Alice Millard and the redoubtable A. S. W. Rosenbach sold Mrs. Doheny some of her most spectacular illuminated manuscripts. The stately Liesborn Gospels date back to the tenth century, when they were presented to a Benedictine nunnery in Westphalia; a late fifteenth-century Crucifixion carved in relief on the front panel of the binding may have been copied from an earlier Romanesque design. An elaborately decorated Parisian manuscript of the late thirteenth century is thought to be "one of the finest Bibles of the period." In 1945 she bought from a dealer in Berkeley a Bolognese manuscript Bible with 74 large historiated initials, some extending the length of the page. Genesis begins with seven roundels depicting the Creation, followed by a Crucifixion and two additional roundels of St. Francis feeding the birds and receiving the Stigmata. A *Bible Historiale* contains nearly a hundred miniatures of Biblical scenes executed by a fifteenth-century artist, whose "dazzling" colors have earned him the name of the Doheny Master.

Mrs. Doheny owned more than a dozen Bibles printed before 1501, including two elegant editions printed by Nicolas Jenson, the first edition in Dutch, an illustrated edition in German, and the first volume of the Gutenberg Bible from the Dyson Perrins collection. This last she considered her most triumphant acquisition. Like Edward Dickson, Mrs. Doheny experienced some frustration in her pursuit of the Gutenberg Bible, having once bid on the Dyson Perrins copy unsuccessfully and having tried to purchase the General Theological Seminary copy, only to have it snatched back from her hands at the very last moment. While the book eluded her, she bought leaves instead (some from the same source that furnished UCLA's Gutenberg leaves) until the Dyson Perrins copy came up for sale again in 1950. She was so pleased with this single volume, gloriously illuminated (possibly by a Mainz artist) and sturdily bound (possibly by a Mainz binder), that she declined the

opportunity to trade up for the Shuckburgh copy in two volumes.

With this crowning achievement, the Doheny Library at Camarillo amounted to about six thousand five hundred volumes, including maybe a hundred rare Bibles in various shapes and sizes. In 1952 the Doheny Library celebrated the five hundredth anniversary of the Gutenberg Bible with a comprehensive exhibit containing one hundred and forty Bibles, some only in single leaves, others in facsimile. Satisfied with what she had accomplished, and suffering from failing eyesight, Mrs. Doheny only occasionally added to her collection in later years. She had erected a magnificent memorial to her husband, enriched the seminary, and augmented the cultural resources of Los Angeles. This was her intention, she confided to Rosenbach in 1947, when she bought from him the Jenson, 1479 Bible on vellum. "I am really thrilled by the beauty of this Bible," she wrote. "The Huntington Library does not have a copy so that means I am adding something new to the art treasures of Southern California."

The Archdiocese interpreted her intentions differently. By the terms of her will, her bequest became an unrestricted gift in 1983, twenty-five years after her death. In 1987 the Archdiocese announced that it would be "redeploying this asset" to endow the seminary and to modernize its library facilities. A lavish color brochure presented the calculated net worth of the Doheny collection at twenty million dollars and explained that the cost of upkeep was so great and that the number of visiting scholars so small that the Archdiocese was paying "an effective subsidy of $1,700 per scholar." During the next two years a series of auction sales in London, New York, and Camarillo dispersed the Doheny Library and gained for the Archdiocese the princely sum of thirty-four million dollars, far more than it anticipated. The Gutenberg Bible went to

Japan at more than five million dollars, another record-breaking price.

This account of Bible collecting in Southern California does not have to end quite so unhappily, for a few Doheny books will remain in Los Angeles. UCLA's Department of Special Collections successfully bid on several lots for the Ahmanson-Murphy Collection of Italian Printing. Nicolas Jenson, the Venetian printer famed for his roman type and his extensive trade, is now better represented at UCLA with some of his earliest printing in the vernacular and with his Latin Bible of 1476 (cat. no. 24). It is particularly appropriate that this Bible should stay in Los Angeles, because it was given to Mrs. Doheny by the lawyer Frank J. Hogan, who encouraged her book collecting efforts and advised other Los Angeles collectors as well. Acquisitions continue to be made in the spirit of Hogan, Doheny, Clark, Huntington, and other ambitious collectors. The Clark Library now has both of the Bibles printed by John Baskerville, the Birmingham printer who revolutionized the typography of the eighteenth century. Within the last few years, UCLA's University Research Library has ordered the New American Bible (1987), the Revised English Bible (1989), and facsimiles of early Bibles in Church Slavonic (1988) and Middle Low German (1979). These new arrivals not only strengthen local libraries but also the entire book collecting community, which thrives on the interchange of books in private hands, on dealer's shelves, and in the exhibit cases of museums and libraries throughout southern California.

MEDIEVAL AND RENAISSANCE MANUSCRIPTS OF THE BIBLE:

AN INTRODUCTION TO THE EXHIBITION AT THE J. PAUL GETTY MUSEUM

Ranee Katzenstein

Assistant Curator of Manuscripts

J. Paul Getty Museum

The Bible with which we are familiar today stands at the end of a long historical development that reaches back to the ancient kingdoms of Israel and Judah. Its complex origins are reflected in the very word "Bible." Like the medieval Latin *biblia*, it is a singular noun, but its original Greek form, *tà biblía*, is plural. The sacred writings of the Judeo-Christian tradition that together comprise the Bible are in fact a number of independent records written over the course of centuries. Only gradually were these documents assembled in a single volume whose contents were firmly established.

The origin of each of these records forms a distinct critical problem. According to tradition, the sacred writings of Judaism, drawn from a literary heritage that spanned almost a thousand years, were restored by the priest Ezra in the fifth century BC following the destruction of Jerusalem by the Babylonians. Other books – some included in the Hebrew Bible and some only in the Greek version of the Old Testament – were written in the centuries that followed, the latest being composed during the first century of the Christian era. By this time, a general consensus had been reached regarding which texts might or might not be recited during public worship or be regarded as authoritative sources of law. Modern scholarship credits an assembly of rabbis meeting toward the end of the first century AD in Jamnia, a town on the shores of the Mediterranean to the west of Jerusalem, with the establishment of the Old Testament canon, that is the authoritative list of books accepted as authentic holy scripture. The books included in the canon were divided into three main groups: Law or *Torah* (the first five books of the Bible, also known as the *Pentateuch*), Prophets, and Writings (*Hagiographa*).

Compared to the Old Testament, the New Testament took form relatively quickly. Its earliest components are the epistles of Saint Paul, which are believed to have been written in the

third quarter of the first century AD. The so-called Synoptic Gospels (i.e., those of Matthew, Luke, and Mark; the name, from the Greek word *synoptikos*, which means "seen together," refers to the numerous parallels to be found in the structure, content, and wording of these three Gospels) were apparently written very shortly thereafter. The identity of the author or authors of the Gospel of Saint John and the Book of Revelation and their dates of composition have been much debated by scholars, but John's Gospel was certainly known by the first half of the second century, and the Book of Revelation probably was as well. A core of essential books accepted and revered by most Christians was established by the end of the second century, and the New Testament canon was fairly well fixed by the end of the fourth. (The books that remained outside the canon comprise the apocryphal New Testament.) However, the precise text of the books of the New Testament and their organization and presentation have continued to be refined even to the present day.

No single essay, and certainly not one as brief as this, can do justice to the complexities and subtleties of these developments. Rather, the aim of the following remarks is twofold. Part one will provide an introduction to the development of the text of the Bible during the Middle Ages and the Renaissance and the various forms taken by biblical manuscripts as illustrated by the volumes in the exhibition. The second part of this essay considers the role of the Bible in the liturgy and in late medieval literature, since it was through these channels that most men and women of the Middle Ages gained what knowledge they had of holy scripture.

Establishing the Text and Format
of the Latin Bible

The great majority of medieval manuscripts of the Bible are written in Latin. This simple fact deserves some consideration since the Old and New Testaments were originally composed primarily in Hebrew and Greek respectively. The earliest translations into Latin were made to serve the needs of the early Christian communities in the western provinces of the Roman empire. These translations never achieved official status or even uniformity. The textual variety that could be found in individual copies of the Bible was already a cause for concern in the fourth century. In a letter addressed to Pope Damasus I in 384 AD, Saint Jerome (circa 331-419/420) decried the difficulties arising from these variations, claiming that there were almost as many different versions of the text as there were manuscripts. In 382, at the pope's request, Jerome had undertaken a revision of the Old Latin text of the Bible (known as the *Vetus Latina*) in order to remedy this situation. Within two years he had completed his revision of the Gospels; his letter of 384 to Damasus was written to accompany this revision when it was presented to the pope. Jerome's work on the books of the Old Testament took much longer (until 405) since it entailed new translations from the original Hebrew.

The revised text met some resistance at first: even Saint Gregory the Great (circa 540-604; pope from 590) stated explicitly that he would not hesitate to quote the Old Latin text if it suited his purposes better than Jerome's version. But the "Vulgate" (from the Latin *vulgatus*, meaning common or widespread), as Jerome's revision has come to be known, was in general use by the seventh century. With the exception of the New Testament in Greek (cat. no. 1) completed in 1133 in Constantinople (modern-day Istanbul), the Vulgate is used in all of the manuscripts in the exhibition.

Saint Jerome's connection with the Bible is much more apparent in medieval manuscripts than it is in the printed editions we use today. Manuscripts of the Bible written in the ninth through twelfth centuries normally contain a number of non-biblical texts associated with the Saint. They frequently begin with Jerome's letter to Paulinus (353/4-431), the bishop of Nola (near Naples) who had ordained him, in which the contents of each of the books of the Old and New Testaments are summarized and interpreted. Jerome's letters to his friend Desiderius and to Pope Damasus concerning his revision of the Gospels often preface the Old and New Testaments respectively, and portions of his commentaries on individual books of the Bible sometimes precede them as prologues.

Jerome began his revision of the Old Testament with the Book of Psalms. The version of the psalms used in all churches in Rome and throughout Italy during the Middle Ages, called the "Roman psalter," is traditionally identified as Jerome's first revision. By about 392 he had completed a second version, called the "Gallican psalter" because of its popularity in medieval Gaul (roughly equivalent to modern-day France and Belgium). Jerome revised the text of the psalter yet again, this time working directly from the original Hebrew; this last version is known as the "Hebrew psalter." The Roman psalter continued to be used in Italy until the time of Pope Pius V (1566-1572), when it was replaced by the Gallican psalter. Outside of Italy, the Gallican psalter appeared in virtually all manuscripts of the Vulgate after the ninth century. It is the Gallican version of the psalter that is normally included in printed editions of the Bible.

These distinctions should not be drawn too sharply, however. There are a number of medieval manuscripts in which two or all three versions of the psalms are set out in parallel columns. These multiple psalters correspond to the interests of biblical scholars of the late twelfth and early thirteenth centuries, in

particular their burgeoning interest in the Hebrew Bible, since Jerome's Hebrew psalter was then considered to be a trustworthy substitute for the Hebrew original. Scholarly notes have been added to the margins throughout the text of the large lectern Bible with a triple psalter that is included in the exhibition (cat. no. 3). The decorated initials marking the divisions of the text in this Bible are painted in the so-called Channel style of late Romanesque England and France.

The Vulgate itself was prey to corruption both through the incorporation of readings from the Old Latin text and through errors introduced by scribes. Much of the subsequent history of the Bible in the Middle Ages is the history of attempts made to recover an accurate text of the Vulgate. Among the earliest and most influential of these attempts were those undertaken for the court of the emperor Charlemagne (742-814), particularly the revision achieved by Alcuin of York (735-804), abbot of the monastery of Saint Martin at Tours, to the southwest of Paris. Charlemagne encouraged the scholars of his realm to improve the quality and consistency of the biblical and liturgical texts circulating throughout his lands. He was genuinely interested in theological matters, but he was also well aware of the contribution that a unified clergy could make to the orderly administration of his empire. Alcuin's revision of the Old and New Testaments was, for the most part, limited to minor corrections of punctuation, orthography, and grammar, although his replacement of the Hebrew psalter with the Gallican contributed significantly to the subsequent dominance of the Gallican version.

Under Alcuin's successors the scriptorium at Tours produced some of the finest manuscripts of the Carolingian age, including sumptuous Bibles that helped diffuse Alcuin's revised text; by the late ninth or early tenth century, Alcuin's revision of the Vulgate was becoming the norm. A leaf from one of the Bibles made in Tours is included in the exhibition (cat. no. 2) .

By using a variety of scripts hierarchically arranged, the scribes of this Bible imparted a clarity and dignity to its text. The classical origins of these scripts and the decorative motifs employed (for instance, the acanthus leaves at the ends of the initial *P*) reflect the enthusiasm for antiquity that permeated the upper levels of Carolingian society. The Bible from which this leaf comes, which belonged to the monastery of Saint Maximin in Trier, was disbound before the end of the fifteenth century. More than fifty other leaves from this Bible (including ten in the J. Paul Getty Museum) have been identified in eight collections throughout Europe and the United States.

"As the third year which followed the year 1000 approached, the sanctuaries of the entire earth, but especially those of Italy and Gaul, were rebuilt . . . One might have thought that the very earth shook off its old age and covered itself everywhere with a white mantle of churches. . . ." The renewal and expansion of religious life reflected in this famous remark of the French monk and chronicler Radulphus Glaber (circa 985- circa 1047) encouraged the production of manuscripts, particularly manuscripts of the Bible. Much of this renewal was centered in the monasteries where, in accordance with precepts set forth in the *Rule* of Saint Benedict (circa 480-circa 550), monks read the Bible regularly as part of their daily devotions. Many of the most magnificently illuminated manuscripts of the Bible that are preserved today were made to be read aloud to monks assembled in their churches during the services of the night Office or in their refectories during meals. Such is the original context of the two lectern Bibles in the exhibition (cat. nos. 4 and 5). The earlier of these manuscripts was made about 1170, probably in the Cistercian monastery of Saint Mary at Pontigny near Sens; by the fourteenth century it belonged to the Premonstratensian abbey of Saint Marianus in nearby Auxerre. The Bible made about one hundred years later for a

monastic house in northern France, probably the Cistercian monastery at Marquette, represents the continuation of this type of Bible into the thirteenth century. Lectern Bibles such as these were designed to be read aloud: their monumental format and large, spaciously laid out text (which often required that they be bound in more than one volume) permitted the reader to remain a comfortable distance from the page so that his voice could carry to the assembled monks.

To read the Bible was also to study it: "Blessed are the eyes which see divine spirit through the letter's veil" wrote Claudius, bishop of Turin, in the ninth century. In the Middle Ages, study of the Bible took place chiefly in the monastery and cathedral schools, the latter gradually transforming themselves into universities as the twelfth century progressed. In this period too, the explanatory notes and extracts from the writings of the Church Fathers that had been gathering around the biblical text itself were being given a more systematic form by Anselm of Laon and other masters teaching at the schools. The result was the Gloss on the Bible (*Glossa Ordinaria*), which circulated in the twelfth century in multi-volume sets in which the texts of individual books of the Old and New Testaments were presented along with this commentary on them.

Laying out the pages of a glossed book presented considerable difficulties, since separate texts of unequal length had to be coordinated with one another over their entire extent. In the earliest glossed manuscripts, the biblical text was copied out first; the commentary was then fitted in as well as it could be. In later glossed volumes, such as the mid-twelfth century glossed psalter in the exhibition (cat. no. 6), the biblical text and its glosses were copied together page by page, a development that suggests the increasing standardization of the Gloss.

In the thirteenth century, with the flourishing of the University of Paris and the rise of the Dominicans and Franciscans (the

so-called preaching orders) there came a transformation in the form of biblical manuscripts. The Bible was the primary text studied at the university; indeed, students were required to bring copies of it with them to class. It was also the key text of itinerant preachers, who were as eager as university students to own handy, portable volumes. Efforts on the part of theologians and booksellers in Paris in the first half of the thirteenth century to meet their needs contributed to the development of the compact single-volume Bible (sometimes called a *porto* from the Latin verb *portare* meaning "to carry"), containing the complete texts of the Old and New Testaments, from Genesis to Revelation, with which we are familiar today. The choice and order of the books contained was regularized, the division of these books into chapters systematized (an important development that facilitated scholars' ability to make references to the text), the selection of prologues chosen to introduce the individual books more or less established, and a glossary of Hebrew names was appended to the text.

Though made in northern France, the pocket Bible in the exhibition (cat. no. 7) is representative of the type developed in thirteenth-century Paris. In many ways it is similar to most modern printed editions of the Bible. The pages are extremely thin, and the text is written in a tiny script arranged in two narrow columns. The order of the books is close to that used today (the Book of Acts follows the epistles of Saint Paul rather than the Gospels) with running titles appearing at the top of every page. Even the chapter divisions are virtually the same (the further division into verses with which we are familiar was unknown before the sixteenth century). We are so accustomed to this format being used for the Bible that we take it for granted; in fact, it was an invention of the thirteenth century.

The revision of the Vulgate made in Paris also had an impact on luxury copies of the Bible being produced for members of

the court and other wealthy individuals. The text of the finely produced and elaborately decorated Parisian Bible in the exhibition (cat. no. 8) incorporates at least some of its innovations. The illumination of the manuscript has been attributed to the so-called "Cholet workshop," a group of anonymous artists named after the patron of some of the manuscripts on which they worked, Jean Cardinal Cholet of Nointel (between Paris and Beauvais). The cusped ornamental extenders stretching out in the margins of its pages, the animated faces, and the convincing drapery folds rendered with shading and subtly drawn lines are all characteristic of the work of this group of artists. The "Cholet workshop" produced a missal (a book containing all the texts necessary to celebrate mass) for the abbey church of Saint-Denis sometime between 1254 and 1286; the Parisian Bible in the exhibition may have similarly been made around this time for an important religious community.

The success of the Paris revision of the Vulgate was also widespread geographically, as can be seen in the Bible made in Bologna between 1265 and 1280 (cat. no. 9). Not only its text but also aspects of its decoration reflect French models, for instance the compositions of the historiated initials that open each of the books of the Old and New Testaments and their flourishes, which extend gracefully into the margins. The numerous representations of Dominican friars that adorn this manuscript's pages suggest that it was made for a Dominican convent. The Dominican order participated actively in the revision of the Vulgate taking place in thirteenth-century Paris, undertaking campaigns to correct the text of the Bible in 1236, 1248, and 1256. It is easy to imagine that friars moving between the Dominican theological school established at Saint-Jacques in Paris and the Dominican convent in Bologna brought a knowledge of French manuscripts of the Bible with them to northeastern Italy.

The Paris Vulgate of the thirteenth century stands behind many of the printed editions of the Bible, including Johannes Gutenberg's Bible, that first began to appear in the second half of the fifteenth century. This is not to say that study and revision of the biblical text did not continue. The mid-fifteenth century Bible made in the scriptorium of the Windesheim Congregation in Cologne that is included in the exhibition (cat. no. 10) represents this ongoing tradition. The Windesheim Congregation was a monastic order under the rule of the Regular Canons of Saint Augustine, which was part of an ascetic movement known as the Modern Devotion (*Devotio Moderna*) that arose in Holland in the late fourteenth century and spread rapidly throughout the Netherlands, Germany, and Switzerland. The text of this manuscript follows the revised version of the Bible prepared at Windesheim and sometimes associated with Thomas à Kempis (circa 1380-1471), the Windesheim canon who was probably the author of *The Imitation of Christ*. The Museum's manuscript appears to have been made for the Cathedral of Cologne, a destination that would account for its elaborate decoration with historiated initials and exuberant foliate and pen-work borders heightened with gold.

In the sixteenth century, scholars such as Erasmus (circa 1469-1536) once again revised the Latin text of the New Testament based on new translations from the original Greek. The Pauline epistles were of special interest to these biblical humanists since Saint Paul's emphasis on faith as the key to salvation corresponded to tenets of their own reform theology. The latest manuscript in the exhibition, the Epistles of Saint Paul written and illuminated in Paris or Tours in the late 1520s (cat. no. 11), reflects the importance Saint Paul's writings assumed in the Reformation (although it does not take into account the specifics of Erasmus' textual scholarship). The miniatures in the manuscript were executed by the finest master

26

associated with a prolific workshop active in the 1520s. Known as the Master of the Getty Epistles, his work combines heroic figure types based on the High Renaissance art of Italy with the mannered elegance and landscape forms of sixteenth-century Flemish mannerist painting.

Communities associated with the *Devotio Moderna* continued to make manuscripts of the Bible in the Renaissance, in large measure as a means of supporting themselves, and a few extravagant patrons such as Federigo da Montefeltro (1422-1482), duke of Urbino, and Borso d' Este (1413-1471), duke of Ferrara, commissioned handwritten and illuminated Bibles whose opulence is renowned. But the tide was turning. The advent of the printing press in the mid-fifteenth century and the rapid and wide diffusion of texts that it made possible signaled a revolution in the ways in which the Bible would henceforth be read and studied.

The Bible in the Liturgy
and in Late Medieval Literature

The image of a medieval reader privately studying his or her personal copy of the Bible is basically inaccurate: most of the manuscripts we have considered thus far were made for religious institutions where they were read aloud to an assembled congregation. Although monks and theologians might read the Bible itself from time to time, much of their knowledge of scripture came from other sources. One important source was the quotations from the Bible that appeared in the writings of the Church Fathers that they studied. But their chief source of knowledge of the Bible, and virtually the only source for most men and women living before the year 1300, was the liturgy in which passages from the Bible were regularly recited.

Reading passages from the Bible is an integral part of the celebration of mass. Of the readings included in every mass, one is always taken from the Gospels. The most sumptuous manuscripts of any portion of the Bible produced in the early Middle Ages were unquestionably volumes containing the four Gospels. The objects of particular veneration, Gospel Books were presented by emperors and princes to the monastic houses and churches under their protection. One of the most important scriptoria producing such volumes in Romanesque Europe was the Benedictine abbey at Helmarshausen in northern Germany. The Helmarshausen scriptorium produced a number of Gospel Books on commission from rulers who then bestowed them on the churches of their realms. The miniatures in the Gospel Book from Helmarshausen in the exhibition (cat. no. 12) exemplify the Romanesque style developed at that influential artistic center. The compositions are constructed from lively patterns and the colors are warm and saturated. The arrangment of the drapery folds, the facial features, and the use of firm black outlines to separate areas of different colors have much in common with the work of Roger of Helmarshausen, a famous metalworker active at the abbey in the early twelfth century.

In the early Church, the Gospel passages were read aloud according to their order in the Bible. By the seventh century, a cycle of readings had been established in which particular passages were assigned to particular days; for instance, passages that narrated the events commemorated by the major feasts of the Church year, such as Christmas or Easter, would be read on those holy days. To help identify the passage to be read on a given day, a list of the passages, identified by their opening and closing words, was normally included in biblical manuscripts (this list is called a "capitulary"). The passages were also numbered according to a system believed to have been devised by Eusebius (circa 260-circa 340), bishop of Caesarea in Pales-

tine and author of the celebrated *Ecclesiastical History*. The numbers of the passages, called Ammonian sections (since they were once thought to have been devised by Ammonius Saccas [circa 175-circa 242]), were often written in the margins of manuscripts of the Bible to help locate a particular reading. Such numbers appear in the margin of the text of the two leaves from an Anglo-Saxon Gospel Book attributed to Canterbury that are included in the exhibition (cat. no. 13).

Most manuscripts of the New Testament written before the thirteenth century also include a set of ten Canon tables that serve as a concordance of the narratives contained in the four Gospels. The system, also conceived by Eusebius, is based on a comparative tabulation of the Ammonian sections. In the New Testament from Pontigny in the exhibition (cat. no. 4), the tables are arranged under decorative arcades enlivened with birds and acrobats. This manuscript also includes Eusebius' "Epistle to Carpianus," in which the author himself explains the system of the Canon tables.

Even with the help of capitularies and marginal numbering, finding the passages assigned for a particular mass in a copy of the Bible could be an onerous process. As early as the late eighth century, a new type of arrangement of the texts in the Bible had been developed to facilitate finding these passages. The new arrangement appears in manuscripts known as Gospel lectionaries, such as the tenth-century example included in the exhibition (cat. no. 14). The Gospel passages are arranged according to the order in which they were to be read at mass throughout the liturgical year. This lectionary opens with the reading for Christmas Eve ("Cum esset desponsata [mater Iesu Maria Ioseph]" ["When Mary the Mother of Jesus was espoused to Joseph"]). The current practice of beginning the church year with the first Sunday of Advent became common only after the year 1000. The beginning of each reading in this volume is

29

highlighted by an elaborate initial made of interlacing gold and silver vine tendrils. Decorated letters in this style are characteristic of the finest manuscripts produced throughout the Ottonian Empire (founded by Otto I of Saxony in 936). The Museum's manuscript is most closely connected with a group of early Ottonian manuscripts that includes a sacramentary, an early form of service book for the mass, written by the scribe Eburnant for Adalbert, who is mentioned as the abbot of the monastery at Hornbach in southwestern Germany in documents dating from 972 to 993.

Recitation of the psalms forms the core of the liturgy of the Divine Office, the services of communal prayer celebrated at each of the eight times of the day that are known as the canonical hours. Manuscripts containing the psalms served as prayer books in the Middle Ages; up until the thirteenth century, these devotional books were with very rare exceptions the only books owned by the laity. The liturgical character of many medieval psalters is clear from the other texts they often include, for instance, a calendar noting important feast days, a litany of saints, and various prayers.

Two psalters from the mid-thirteenth century are displayed in the exhibition (cat. nos. 15 and 16). Both begin with a series of full-page miniatures depicting the Life of Christ. These scenes were a reminder that Christ was descended from King David, the presumed author of the psalms. The relationship is emphasized in the initial *B* that opens the first psalm in the psalter made in Würzburg, where David and Christ are not only linked to one another compositionally but actually resemble each other. The psalter made in Paris also includes a cycle of miniatures illustrating scenes from Genesis. The French captions that accompany them indicate that the manuscript was made for a lay man or woman.

The leaf with scenes from the life of King David on

exhibition (cat. no. 17) may have also been part of a prefatory cycle of miniatures from a deluxe psalter. It comes from the so-called "Old Testament Picture Book" now in the Pierpont Morgan Library, New York (two additional leaves are preserved in the Bibliothèque Nationale, Paris). One of the most magnificently illuminated volumes to be produced in France or England in the thirteenth century, it illustrates more than 350 scenes from the Books of Genesis, Exodus, Joshua, Judges, Ruth, and Kings. No portion of the original text survives (the Latin inscriptions were added in the fourteenth century, the Persian inscriptions in the seventeenth, to identify the subjects depicted) and it has been suggested that the volume was intended from the outset as an elaborate picture Bible. The miniatures are in fact more closely related in many ways to mural painting and stained glass than they are to book illumination.

The manuscript containing the text of the Book of Revelation (cat. no. 18), made in London in about 1250, and something of a picture book itself, should also be seen in the context of lay devotion. A fashion for richly illustrated copies of Saint John's Apocalypse developed in England in the mid-thirteenth century. The events described in this book must have seemed particularly relevant at that time: the twelfth-century monk Joachim of Fiore had prophesied that the end of the world would occur in 1260, and his prophecy was widely believed; the actions of Emperor Frederick II (1194-1250) allowed him to be identified with the Antichrist; and calamitous events such as the fall of Jerusalem, the prize of the Crusades, to the Moslems in 1243 and the invasions of Europe by the Tartar armies in 1237 and 1241 suggested the end of the world was near. Many of the thirteenth-century English Apocalypse manuscripts that survive contain excerpts from a commentary on the text written by an otherwise little-known monk called Berengaudus. These excerpts focus on the themes of good, evil, and redemption; their

31

selection suggests that these manuscripts may have been designed as devotional or instructional volumes.

The Museum's Apocalypse manuscript contains eighty-two half-page miniatures that allowed those perusing its pages to contemplate the scenes described by Saint John by means of pictures in addition to the text. Remarkable for their lively interpretation of Saint John's vision, the miniatures include the saint himself witnessing the extraordinary events that he would later recount. The figures have been outlined in pen and ink and then modeled with thin, colored washes. The elegant poses, graceful contours, and decorative patterns of drapery folds found in these miniatures reveal early Gothic illumination in England at its finest.

Although the illustrations of the Apocalypse manuscript and the "Old Testament Picture Book" follow the text of the Bible closely, they are imbued with the courtly sensibilities of aristocratic society. With their vivid representations of thirteenth-century costumes and settings, they present the events recounted in the Bible in the guise of chivalric romance. It is not surprising that the biblical narratives, with their tales of Old Testament heroes and heroines, inspired the imaginations of the knights and courtiers of late medieval Europe. Beginning in the thirteenth century, literary chronicles based on the historical events recounted in the Bible and written in the vernacular provided an additional source of information about the contents of scripture.

One of the most ambitious biblical histories of the late Middle Ages was the *Weltchronik* ("World Chronicle") of Rudolf von Ems (active 1220-1254), a history of the world from Creation up to the time of King Solomon. By the 1340s, his text had been interspersed with portions of other chronicles to create a more extensive narrative in which the events of biblical, apocryphal, and ancient secular history were combined. Written

in Middle High German rhymed couplets, the *Weltchronik* was well suited to being read aloud; historical narratives were often recited at aristocratic gatherings as a form of entertainment. The *Weltchronik* in the exhibition (cat. no. 20) is the most lavishly illuminated of the numerous copies of the text that survive. Executed in Regensburg in southern Germany sometime around the first decade of the fifteenth century, its miniatures combine the innovations of the International Style with the bold colors and vigorous modeling characteristic of south German and Bohemian art.

In France, at the very end of the thirteenth century, a summary of biblical history called the *Historia Scholastica*, which was first compiled in the twelfth century by Petrus Comestor (circa 1100-1178), was translated into the vernacular by Guiart des Moulins. Petrus had woven accounts from scripture together with the writings of pagan and patristic authors to create a continuous history from Creation to the end of the period covered by the New Testament Book of Acts. Guiart's translation, which is known as the *Bible Historiale*, proved to be extremely popular; over seventy manuscripts of the text are known. The *Bible Historiale* in the exhibition (cat. no. 19) is a luxurious two-volume copy from around 1375. It contains over seventy miniatures executed by the Master of Jean de Mandeville and another artist. Brightly colored backgrounds provide a foil for the grisaille figures, whose sculptural quality is enhanced by the contrast. Volumes illuminated in this delicate style were highly sought after at the court of the French King Charles V (1337-1380) and the Museum's *Bible Historiale* was no doubt intended for the library of an aristocratic patron.

These literary pleasures of the aristocracy were soon to be shared by the non-aristocratic: as the following essay reveals, the advent of the printing press in the middle of the fifteenth

century made the Bible – and with it the chronicles based on biblical history – available as never before. Such availability had never been dreamed of by the scholars and artists who had established and produced the texts of the Bible for centuries. Their heroic efforts to understand and preserve scripture produced the magnificent volumes that are the subject of this exhibition.

<center>* * *</center>

A number of excellent publications on the history of the Bible in the Middle Ages and Renaissance are available and the author would like both to acknowledge her debt to them and recommend them to those interested in pursuing further the issues discussed in this essay: *The Cambridge History of the Bible*, vol. 1: *From the Beginnings to Jerome*, P. R. Ackroyd and C. F. Evans, eds. (Cambridge, 1970) and vol. 2: *The West from the Fathers to the Reformation*, G. W. H. Lampe, ed. (Cambridge, 1969); W. Cahn, *Romanesque Bible Illumination* (Ithaca, New York, 1983); B. Smalley, *The Study of the Bible in the Middle Ages* (Oxford, 3rd. rev. ed., 1983); C. de Hamel, *Glossed Books of the Bible and the Origins of the Paris Booktrade* (Woodbridge, Suffolk, 1984); and *Le Moyen Age et la Bible*, P. Richi and G. Lobrichon, eds. (Paris, 1984). For additional information on the individual manuscripts discussed, see A. von Euw and J. Plotzek, *Die Handschriften der Sammlung Ludwig*, 4 vols. (Cologne, 1979-1985), and *The J. Paul Getty Museum Journal* 13 (1984) and subsequent volumes.

<center>34</center>

MEDIEVAL AND RENAISSANCE MANUSCRIPTS
OF THE BIBLE
THE J. PAUL GETTY MUSEUM

compiled by
Ranee Katzenstein

Establishing the Text and Format
of the Latin Bible

1. Greek New Testament
 Written by Theoktistos, Constantinople, 1133.
 Ms. Ludwig II 4, fol. 106v: *Portrait of Saint John.*

2. Single leaf from a Carolingian Bible
 Tours, circa 845.
 Ms. Ludwig I 1, fol. 10: Initial *P*(aulus).

3. Lectern Bible
 Northern France or England, circa 1180-1190.
 Special Collections Department, University of California,
 Santa Barbara (not foliated): Triple Psalter.

4. New Testament
 Probably Pontigny, circa 1170.
 Ms. Ludwig I 4, fols. 13v-14: Canon Tables.

5. Lectern Bible
 Northern France, probably Lille, circa 1270.
 Ms. Ludwig I 8, vol. I, fol. 10v: Historiated Initial *I* with *The Six Days of Creation and the Crucifixion.*

6. Glossed Psalter
 France, mid-twelfth century.
 The Bancroft Library, University of California, Berkeley,
 Ms. 147, fols. 49v-50: decorated initials.

7. Pocket (*Porto*) Bible
 Northern France, circa 1250-1260.
 Ms. Ludwig I 7, fol. 209v: Decorated initial *A* (opening of the Book of Judith).

8. Bible
 Paris, circa 1260.
 Special Collections Department, University of California, Santa Barbara (not foliated): Historiated Initial *E* with *Jonah Emerging from the Mouth of the Whale* (opening of the Book of Jonah).

9. Bible
 Bologna, circa 1265-80.
 Ms. Ludwig I 11, fol. 222v: Historiated initials *L* with *Portrait of a Monk* and *I* with *King Ahasuerus, Queen Esther, and the Deposed Queen Vashti.*

10. Bible made by the Windesheim Congregation
 Cologne, circa 1450.
 Ms. Ludwig I 13, fol. 39v: Historiated initial *L* with *God Speaks to Moses.*

11. Epistles of Saint Paul
 France, circa 1520-1530.
 Ms. Ludwig I 15, fol. 5v: *Saint Paul.*

The Bible in the Liturgy
and in Late Medieval Literature

12. Gospel Book
 Helmarshausen Abbey, Germany, circa 1120-1140.
 Ms. Ludwig II 3, fol. 52: decorated text page.

13. Two leaves from an Anglo-Saxon Gospel Book
 Attributed to Canterbury, circa 1000.
 Ms. 9: *Christ Teaching His Apostles*; *The Tribute Money,* and
 The Miracle of the Gadarene Swine.

14. Gospel Lectionary
 Reichenau, Germany or Saint Gall, Switzerland, third quarter of the tenth century.
 Ms. 16, fol. 2: decorated initial *C*(um).

15. Psalter
 Würzburg, circa 1240-1250.
 Ms. Ludwig VIII 2, fol. 11v: Historiated initial *B* with *Christ Enthroned and King David with Two Musicians.*

16. Psalter
 Paris, circa 1250-1260.
 Ms. Ludwig VIII 4, fols. 17v-18: *Scenes from the Story of Joseph* (Gen. 41:1-42:29).

17. Leaf from a Picture Cycle of the Old Testament
 France or possibly England, circa 1250.
 Ms. Ludwig I 6, recto: *Scenes of King David and His Son Absalom* (II Kings 15:13-16:10; 21-22).

18. Apocalypse, with commentary by Berengaudus
London, circa 1250.
Ms. Ludwig III 1, fols . 20v-21: *Saint Michael and His Angels Defeat the Seven-Headed Dragon*; *The Devil Comes in a Great Fury.*

19. Petrus Comestor, *Bible Historiale*, translated by Guiart des Moulins
Paris, circa 1375.
Ms. 1, vol. 2, fol. 86v: *Jeremiah Before Jerusalem in Flames.*

20. Rudolf von Ems, *Weltchronik*
Regensberg, circa 1400-1410.
Ms. 33, fol. 89v: *Moses Sees the Backside of God's Head; Moses' Shining Face and the Ark of the Covenant.*

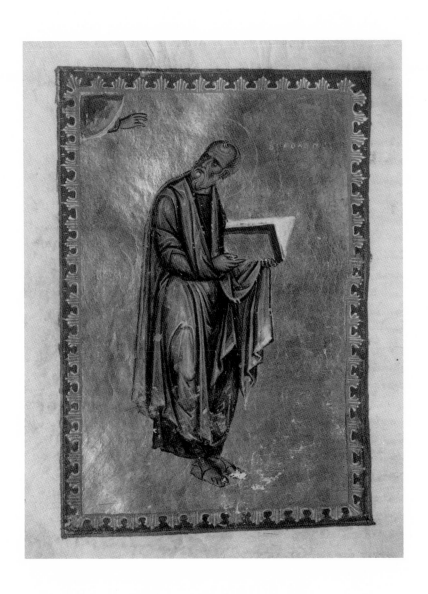

1. Greek New Testament
 Written by Theoktistos, Constantinople, 1133.
 Ms. Ludwig II 4, fol. 106v: *Portrait of Saint John.*

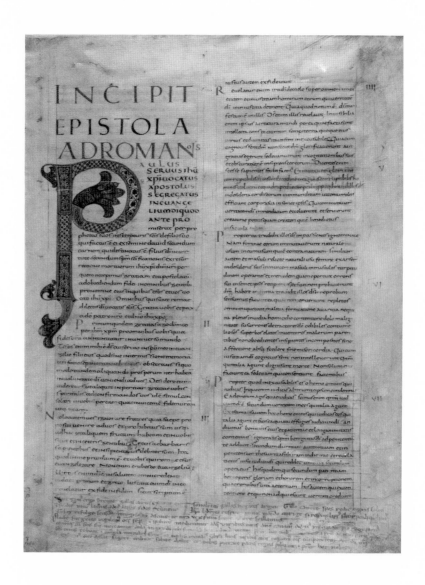

2. Single leaf from a Carolingian Bible
 Tours, circa 845.
 Ms. Ludwig I 1, fol. 10: Initial *P*(aulus).

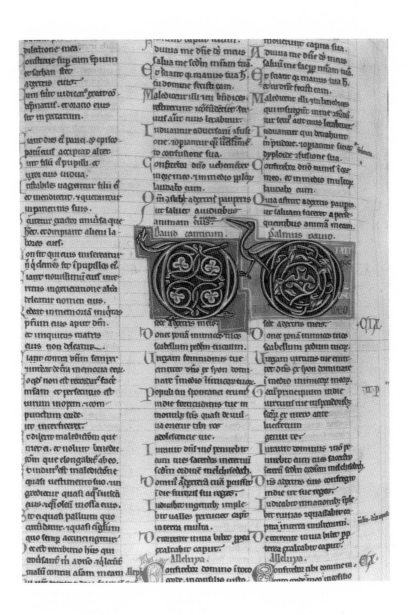

3. Lectern Bible
Northern France or England, circa 1180-1190.
Special Collections Department, University of California,
Santa Barbara (not foliated): Triple Psalter.

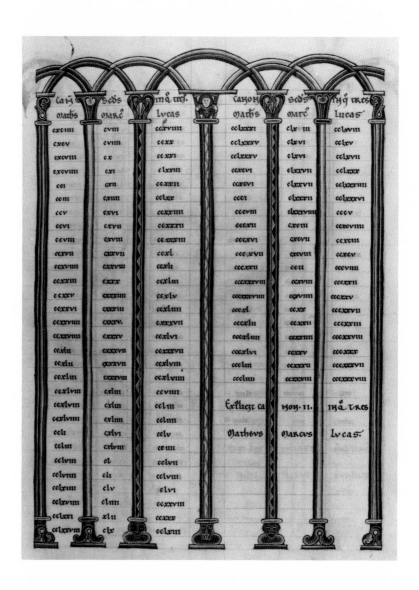

4. New Testament
 Probably Pontigny, circa 1170.
 Ms. Ludwig I 4, fols. 13v-14: Canon Tables.

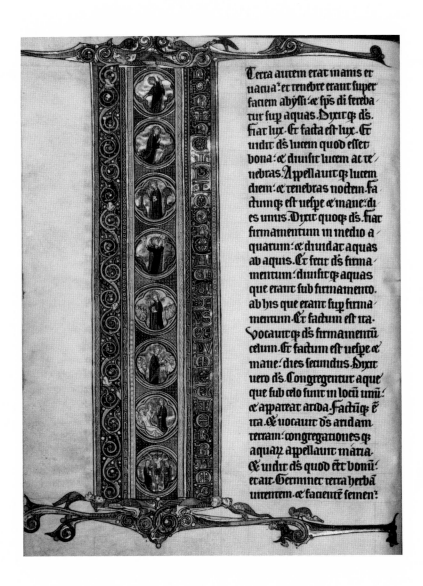

5. Lectern Bible
 Northern France, probably Lille, circa 1270.
 Ms. Ludwig I 8, vol. I, fol. 10v: Historiated Initial *I* with *The Six Days of Creation and the Crucifixion.*

6. Glossed Psalter
France, mid-twelfth century.
The Bancroft Library, University of California, Berkeley,
Ms. 147, fols. 49v-50: decorated initials.

7. Pocket (*Porto*) Bible
 Northern France, circa 1250-1260.
 Ms. Ludwig I 7, fols. 209v-210: Decorated initial *A* (opening
 of the Book of Judith).

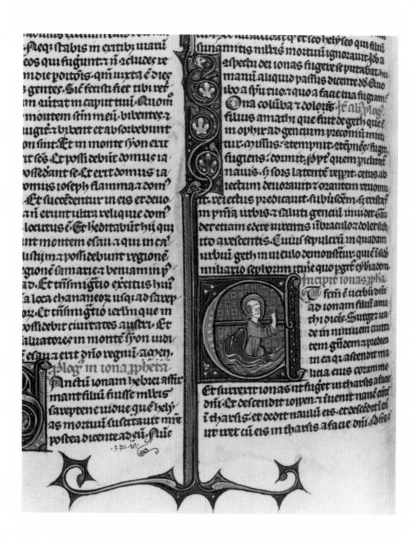

8. Bible

Paris, circa 1260.

Special Collections Department, University of California, Santa Barbara (not foliated): Historiated Initial *E* with *Jonah Emerging from the Mouth of the Whale* (opening of the Book of Jonah).

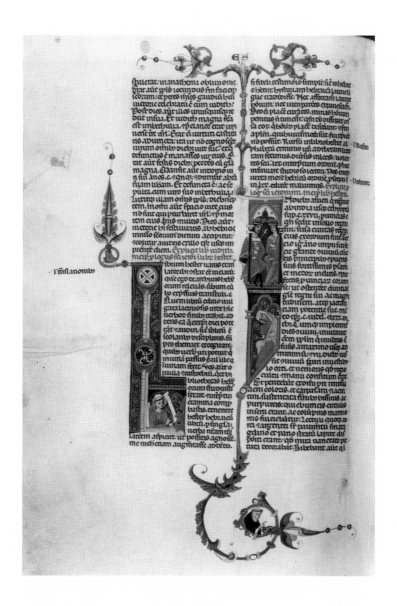

9. Bible

Bologna, circa 1265-80.

Ms. Ludwig I 11, fol. 222v: Historiated initials *L* with *Portrait of a Monk* and *I* with *King Ahasuerus, Queen Esther, and the Deposed Queen Vashti.*

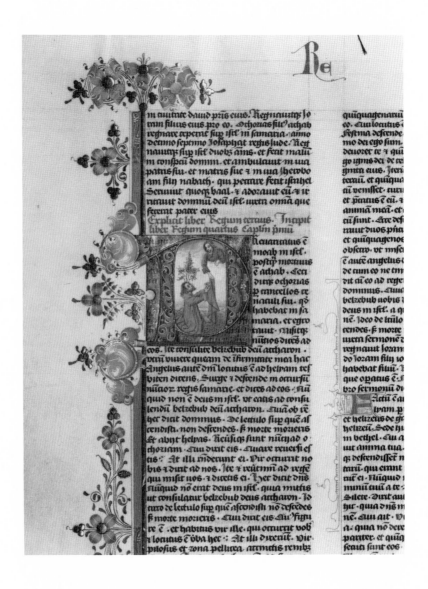

10. Bible made by the Windesheim Congregation
Cologne, circa 1450.
Ms. Ludwig I 13, fol. 39v: Historiated initial *L* with *God Speaks to Moses.*

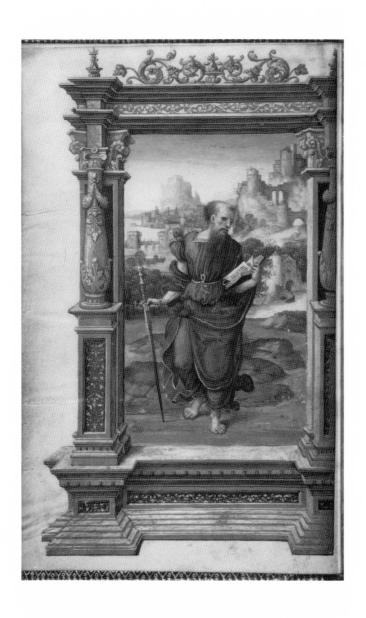

11. Epistles of Saint Paul
 France, circa 1520-1530. Ms. Ludwig I 15, fol. 5v: *Saint Paul.*

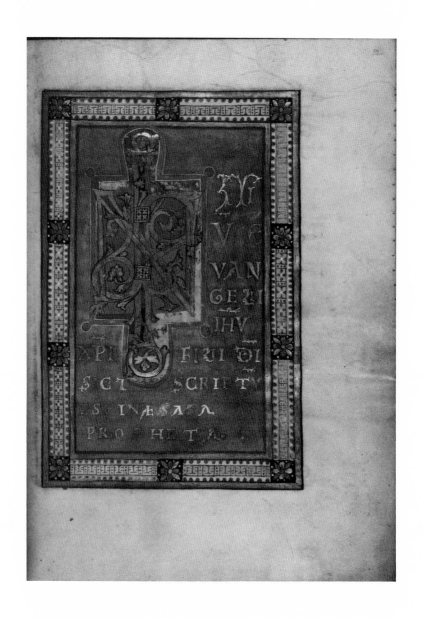

12. Gospel Book
 Helmarshausen Abbey, Germany, circa 1120-1140.
 Ms. Ludwig II 3, fol. 52: decorated text page.

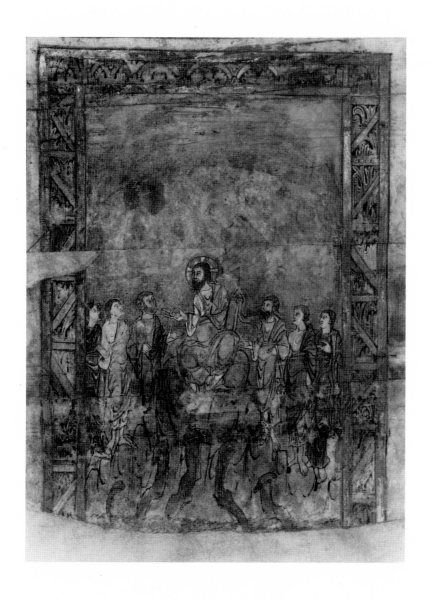

13. Leaf from an Anglo-Saxon Gospel Book
Attributed to Canterbury, circa 1000.
Ms. 9: *Christ Teaching His Apostles.*

14. Gospel Lectionary
 Reichenau, Germany or Saint Gall, Switzerland, third
 quarter of the tenth century. Ms. 16, fol. 2: decorated initial
 C(um).

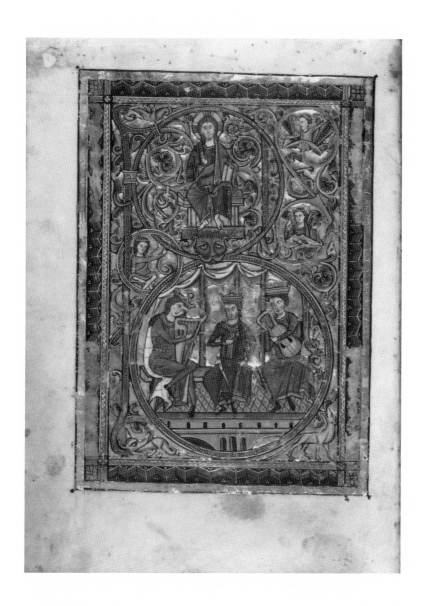

15. Psalter
 Würzburg, circa 1240-1250. Ms. Ludwig VIII 2, fol. 11v:
 Historiated initial *B* with *Christ Enthroned and King David
 with Two Musicians.*

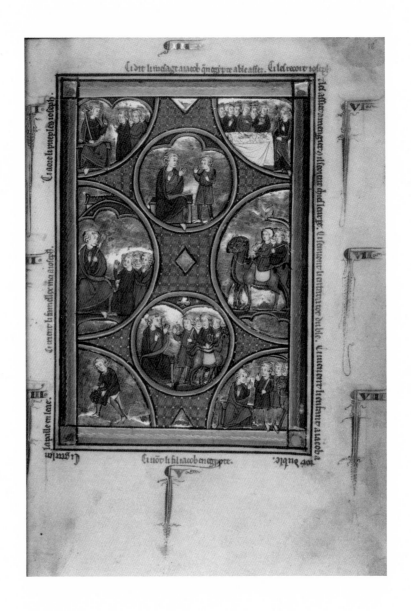

16. Psalter
 Paris, circa 1250-1260.
 Ms. Ludwig VIII 4, fol. 18: *Scenes from the Story of Joseph*
 (Gen. 41:1-42:29).

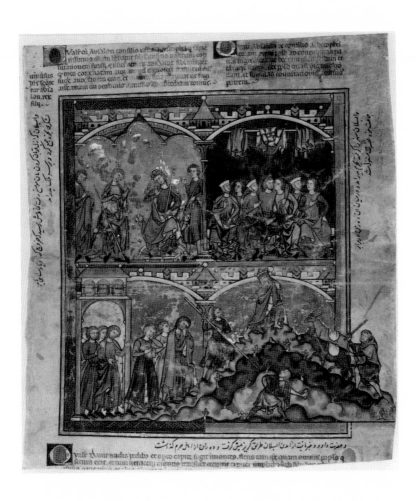

17. Leaf from a Picture Cycle of the Old Testament
France or possibly England, circa 1250.
Ms. Ludwig I 6, recto: *Scenes of King David and His Son
Absalom* (II Kings 15:13-16:10; 21-22).

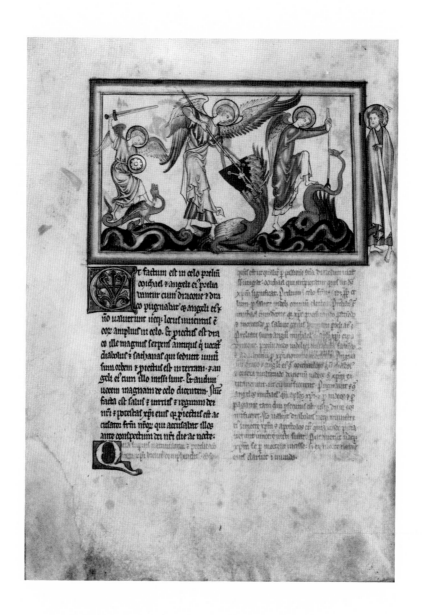

18. Apocalypse, with commentary by Berengaudus
London, circa 1250.
Ms. Ludwig III 1, fol. 20v: *Saint Michael and His Angels Defeat the Seven-Headed Dragon.*

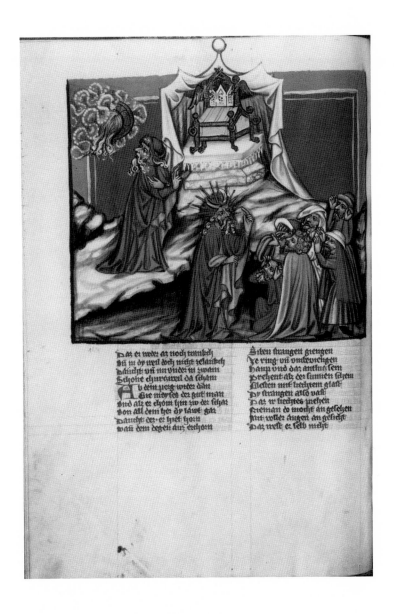

20. Rudolf von Ems, *Weltchronik*
 Regensberg, circa 1400-1410.
 Ms. 33, fol. 89v: *Moses Sees the Backside of God's Head;*
 Moses' Shining Face and the Ark of the Covenant.

The Printed Word: An Introduction To The Exhibition at UCLA

David S. Zeidberg
Head, Special Collections
UCLA

In the beginning was the Word, and the Word was with God, and the Word was God. . . . In him was life; and the life was the light of men. And the light shineth in darkness (John 1:1-5)

From the middle of the fifteenth century, the word of God, which had been limited for the most part to nuns and monks in the abbeys and monasteries and the priests in the churches, spread throughout western Europe with the invention of printing. Johannes Santritter, in his 1483 edition of Eusebius' *Chronicon*, notes in the entry for 1457:

For a method of printing was devised in 1440 by the clever genius of Johann Gutenberg, a knight of Mainz. In this time, it has been extended to almost all parts of the world. The whole of antiquity, being collected in a small piece of brass, is read by posterity in an infinite number of volumes. [Eusebius, bp. of Caesarea. *Chronicon*. Venice: Ratdolt, 1483, f.v3v]

This is thought to be the earliest acknowledgment in print of Gutenberg as the inventor of the movable type printing process in the West. His forty-two line Bible, printed probably in 1454 or 1455, is acknowledged as the first complete book printed by this method. Santritter and Ratdolt must have seen a copy of the Bible in Venice within a year or two of its publication in Mainz. And, if we are to believe their date of 1440, Gutenberg labored fifteen years to perfect the design of his typeface, the process of punching matrices and casting type which was reusable, of setting pages and organizing quires, of developing resources, such as his paper supply, and organizing a production schedule. There are almost as many credits of his achievement as there are editions of the Bible today, but it is a feat not to be taken lightly. The dissemination of the Bible over the past five hundred and some odd years has been the light in the darkness, a light which has touched almost every corner of the world and illuminated almost every written language.

UCLA's part of *A Thousand Years of the Bible*, "The Printed Word," focuses on some of the landmark editions and unusual productions of the Bible from Gutenberg to the present which are to be found in the Department of Special Collections of the University Research Library. As John Bidwell has already mentioned in his introduction, the Gutenberg leaf we are exhibiting (cat. no. 21) was the gift of University of California Regent Edward A. Dickson, and one of three leaves owned by the library. It is folio 509, containing parts of 2 Maccabees, x-xi, and is from one of the approximately 150 to 165 paper copies of the Bible which Gutenberg printed. Only forty-eight complete, or nearly complete copies (lacking only a few leaves), are known to survive. A vellum copy is at the Henry E. Huntington Library in San Marino.

Many readers of this catalog are probably aware of UCLA's collection of early Italian printing and that the Ahmanson-Murphy collections form the core of this research resource, which has received additional support from the J. Paul Getty Trust. The first Bible printed in Rome was that of Konrad Sweynheym and Arnold Pannartz in 1471 (cat. no. 22). Sweynheim and Pannartz, who migrated over the Alps from Germany, were the first printers in Italy. They printed three books in Subiaco, and then proceeded to Rome. The first dated book printed in Italy is their 1465 Subiaco edition of Lactantius. Their 1471 Bible is, after the 1462 Fust and Schoeffer edition at Mainz, the second dated Bible. It is also the first Bible printed, appropriately, in Roman type, and the only Bible printed in Rome during the fifteenth century.

The illumination on the page exhibited has been attributed to the Florentine Giuliano Amedei by UCLA History Professor Richard Rouse. As an interesting sidenote, the Department of Special Collections also owns the 1470 Sweynheim and Pannartz edition of St. Thomas' *Catena aurea super quattuor*

evangelistas, which has similar marginal illumination by Amedei, although the Bible and the Aquinas have entirely different provenances and were reunited at UCLA more than five hundred years after leaving Amedei's studio.

Three other Bibles exhibited here represent mileposts in fifteenth century Italian printing. The first Bible printed in Venice was the 1475 edition of Franz Renner and Nikolaus von Frankfurt (cat. no. 23), a small folio printed in a gothic type in two columns. Nicolas Jenson followed a year later with the first of his two Latin editions (cat. no. 24). It is one of the earliest Bibles with signatures printed as part of the text.

Jenson was a Frenchman from Sommevoire, trained in engraving and known to have worked at both the Paris and Tours mints. Three years after the Gutenberg Bible appeared, he was sent to Mainz by Charles VII to study printing. In 1468, he migrated to Venice and established his press, his first four books appearing in 1470. The UCLA copy of the 1476 Bible was purchased at the Estelle Doheny sale. It had been a 1934 Christmas gift from her husband's attorney, Frank J. Hogan.

The last of our fifteenth century representatives is the 1498 Bevilacqua edition (cat. no. 25), important for its reprinting of the Malermi Bible woodcuts from the 1490 *Biblia vulgare istoriata* published by Lucantonio Giunta. Malermi was a monk whose translation of the Bible into Italian was first printed by Wendelin de Spira in Venice in 1471. Wendelin's was the first of ten fifteenth century editions to appear. The 1490 edition by Giunta was the first to make use of the woodcuts which Bevilacqua reused in this 1498 edition, the second in his quarto format for the Bible.

One of the more ambitious efforts in Bible publishing began in the early sixteenth century – the printing of polyglots, multilingual texts of scripture in its original languages in parallel columns, sometimes across two open pages. Aldo Manuzio, the foremost printer in Italy at the turn of the sixteenth century,

65

suggested the design as early as 1501, but did not produce a polyglot himself. The first to appear was not a complete Bible, but the Psalms, published in Genoa by Pietro Paolo Porro in 1516 (cat. no. 26). Porro printed in eight columns across two pages the Hebrew, a Latin translation of the Hebrew, the Latin Vulgate, the Greek, the Arabic, the Chaldean (in Hebrew characters), a Latin version of the Chaldean, and scholia, which are commentaries on the text in Latin by the editor Agostino Giustiniani, Bishop of Nebbia.

Not only is the Porro polyglot the first to be printed, but it also contains one of the earliest biographies of Christopher Columbus and an account of his voyages, which runs to five columns in the Scholia, beginning on leaf C7r (displayed in the exhibit). Bishop Giustiniani was also a native of Genoa, and he justifies his introduction of Columbus in the gloss on Psalm XIX by stating:

> "The sound of them went out into all the world, and their words to the ends of the earth": Notably in our time in which, by the wonderful daring of Christopher Columbus of Genoa, almost another whole world has been discovered and added to Christendom. But in truth since Columbus used frequently to foretell that he had been chosen by God so that through him this prophesy should be fulfilled, I have thought it not inapposite to insert his life in this place . . . [translated by Nicolas Barker]

The first complete Bible in polyglot, known as the "Complutensian," was produced under the direction of Cardinal Ximines, and so designated from the Latin name of Compluto for the city of Alcala de Henares where the Bible was published in 1521. It was a labor of almost two decades which Cardinal Ximines did not live to see finished. He had assembled scholars in Alcala as early as 1502 to prepare the various language texts from the best manuscripts available.

The second great polyglot Bible, known as the Antwerp or Plantin polyglot (cat. no. 35), did not appear until 1571-73. Its languages include Hebrew, Chaldean, Greek, Latin, and Syriac. It was commissioned by King Philip II of Spain, who asked Benedictus Arias Montanus to serve as the general editor. Montanus based the Plantin text on the Complutensian and spent four years correcting the text against other single text editions. The Hebrew, for example, was derived from the Complutensian, with further emendations from the three editions of the *Biblia Rabbinica* printed by Daniel van Bomberghen in Venice, 1516/17, 1524/25, and 1546-48 (cat. no. 31). The Greek text was revised from the Complutensian against the Aldine edition of 1518 (cat. no. 27), the first complete Bible printed in Greek. The Dutch printer Christopher Plantin complemented Montanus' scholarship by making this edition of the polyglot Bible into one of his great printing achievements. Accounts vary as to the number of copies printed, ranging from 500 to 980, many of which were lost in a shipwreck in one of the first shipments from Antwerp to King Philip in Spain.

Besides the polyglots, sixteenth century editors and printers produced other notable editions as the printed word continued to spread. In Paris, for example, Robert Estienne printed his first edition of the Bible in 1528 (cat. no. 29), which is considered to be the first attempt at producing a critical edition of the scriptures. Estienne set the precedent Montanus was to use fifty years later in the Plantin polyglot, by using three manuscripts of scripture and the Complutensian, among other printed editions, in compiling his text. In later editions, Estienne gained access to more manuscripts and printed editions in an effort to produce more accurate versions supported by textual scholarship.

While the Complutensian, Estienne, and Plantin Bibles are but three examples of efforts throughout the sixteenth century to produce scholarly correct editions of the Bible, none of these

nor any of the others undertaken during the century was accepted as the authorized version by the Catholic Church. One of the most fascinating stories about the production of authorized papal editions of the Bible occurred at the end of the century when Pope Sixtus V decided to fulfill the canon of scripture adopted at the Council of Trent in 1564 to produce an authorized and revised edition of the Vulgate. Sixtus actually participated in the editing and proof-reading of the text, the result being the *Biblia sacra* printed by Aldo Manuzio the Younger, under the imprint Ex typographia Apostolica Vaticana, in 1590 (cat. no. 38). Sixtus sought to protect this version by issuing with it a papal bull which stated this to be the "true, legitimate, authentic, and authorized" Vulgate, and which prohibited any revision under the penalty of excommunication. Unfortunately, this edition still contained errors, as emendations pasted over original text show (see illustration).

Sixtus died in 1590, and his successor Clement VII had the 1590 Vulgate withdrawn. Two years later, Clement issued a new Vulgate with thousands of corrections, both typographical and theological. The new text was issued under the same imprint with the new date of 1592 (cat. no. 40). Its text followed more scholarly ideas about the scripture, as had been recommended, for example, by the theological faculty at Louvain earlier in the century. And to avoid the 1590 order forbidding revision, Clement simply issued the 1592 version with Sixtus' name on the title page and the identical papal bull warning against unauthorized revisions. This edition came to be known as the Clementine Bible and remains the standard, authorized version of the Church to this day.

While there continued to be movement toward scholarly correct and authorized editions of the Bible during the first one hundred fifty years of printing, there was also an effort toward spreading the text further through modern vernacular transla-

tions. The earliest vernacular edition of the Bible appeared less than a dozen years after Gutenberg – the 1466 German Bible printed in Strassburg by Johann Mentel. First appearances of the Bible, in part or complete, in other modern languages in the fifteenth century include Italian (1471, the first Malermi edition), Czech (1475), French (1476), Dutch (1477), Catalan (1478), English (1483), and Bohemian (1488).

Yet the publication of the Bible in vernacular languages was not as widespread initially as one might have expected, owing in part to the belief in some clerical circles that to print the scriptures in any languages other than the "original" Hebrew, Latin, Greek, Arabic, or Chaldean manuscripts was heresy. Considered as a representative source, Frederick Goff's census of *Incunabula in American Libraries* (Millwood, NY: Kraus Reprint, 1973) bears out this theory. Of the fifteenth century editions of the Bible in North America which Goff cites, twenty-eight are in Hebrew, ninety-three in Latin, and twenty-seven in all modern languages combined.

In England, for example, no complete Bible or part of the Bible was printed as a separate work in English in the fifteenth century. The 1483 work cited above actually refers to Caxton's translation of Voragine's *Legenda aurea* (*The Golden Legend*), a work which included lives of the saints based upon biblical texts. Caxton was able to incorporate parts of Genesis, Exodus, and the New Testament as the source material for Voragine's lives. The Bible in English as a work in and of itself did not appear until 1525 with the publication of the New Testament edited by William Tyndale. The first complete English Bible, edited by Miles Coverdale, was printed in 1535. Both of these were printed on the Continent, in Cologne and Marburg respectively, and not without some peril from the anti-Lutheran clergy, both in England and on the Continent. Tyndale's New Testament appeared with a London imprint in 1536, and James

Nicholson printed an edition of Coverdale in London in 1537, the first two English language editions actually printed in England.

Edwin A. R. Rumball-Petre, in his *Rare Bibles . . .* (New York: Duschnes, 1954), lists these four and no fewer than fifty-eight other English Bibles which he considers significant editions of the sixteenth century. For the purposes of this exhibition, we have chosen two representatives – the Bishops' Bible of 1568 (cat. no. 34) and the 1589 edition of the Geneva Bible (cat. no. 36), the latter one of one hundred fifty editions of this version printed between 1560 and 1640. The first edition of the Geneva version appeared in 1560, the product of reformationists John Knox and William Whittingham who fled England during the counter-reformation of Queen Mary. A proclamation of 1553 banned the reading of the Bible in English translation, followed by another, two years later, forbidding even the possession of the Tyndale and Coverdale versions. The edition shown contains an introduction by Calvin, and its annotations reflect its Puritan writers.

While the Church of England was obviously not happy with Mary's reconciliation with the papacy, it was also not pleased with the Puritan orientation of the Geneva version. In 1564, the same year that the Council of Trent adopted its canon of scriptures leading to the authorized Roman Catholic versions of 1590 and 1592 noted above, the Church of England undertook its own version of an English language Bible under the general editorship of Matthew Parker, Archbishop of Canterbury. He, and the other bishops responsible for the project, returned to the text of Archbishop Cranmer's Great Bible of 1539. Their completed work was printed by Richard Jugge in London in 1568 and is considered one of the great achievements of the sixteenth century, not only for its theological criticism but also for its design and typography.

The 1602 edition of the Bishops' Bible formed the basis for the King James version of 1611. The dispute over liturgy and ritual between the Puritans and the Church of England had continued into the seventeenth century. At the Hampton Court Conference of 1604, James put an end to the textual side of the controversy by deciding to produce a new English version – a revision based upon the Bishops' Bible, but including the Geneva as a source, as well as the Tyndale, Coverdale, and Great Bible, and Hebrew, Greek, Latin, French, Italian, and Spanish editions. Almost fifty editors worked on the text from 1607 to the time it went to press in 1610; they were divided into six companies at London, Cambridge, and Oxford, each with original assignments which were then circulated in draft to the other companies for review. A select committee reviewed all commentary and made the final revisions. The King James Bible of 1611 became the authorized version of the Church of England, and remained so until it was revised again during the period 1881-85.

Returning to the Bibles printed in vernacular languages, we have chosen from our collections a representative group from the seventeenth and eighteenth centuries. Four examples will serve here: the 1648 Bible (cat. no. 43) is the first edition of the New Testament printed in Romanian and the basis for all subsequent editions in that language. Each of the books is preceded by the translator's interpretive preface. The 1717 Russian Bible (cat. no. 48) is one of the earliest editions of the Gospels printed in Church Slavonic, the language used for religious printing in Russia. The 1733 Armenian Bible (cat. no. 49) is the third edition in that language, and for the most part a reprint of the 1666 first edition printed in Amsterdam. Its illustrations are based upon the Christoffel van Sichem wood engravings of the earlier edition and are further enhanced in the UCLA copy by their hand coloring. The 1770 Welsh Bible

(cat. no. 52) is the first edition printed in Wales. (The first Bible printed in Welsh was translated by Bishop William Morgan and printed in London in 1588.)

Finely printed editions of the Bible have become a tradition in printing history. John Baskerville's 1769 English version (cat. no. 51) set new standards in typography, for example, which would influence the fine press movement in England and America in the late nineteenth and early twentieth century. William Morris, one of the proponents of the movement, tried to return to the style of the fifteenth century book as the model of elegance. In *A Note by William Morris on His Aims in Founding the Kelmscott Press* (Hammersmith, 1898) he stated:

> . . . I have always been a great admirer of the calligraphy of the Middle Ages, and of the earlier printing which took its place. As to the fifteenth century books, I had noticed that they were always beautiful by force of the mere typography, even without the added ornament, with which many of them are so lavishly supplied. And it was the essence of my undertaking to produce books which it would be a pleasure to look upon as pieces of printing and arrangement of type. Looking at my adventure from this point view then, I found I had to consider chiefly the following things: the paper, the form of the type, the relative spacing of the letters, the words, and the lines; and lastly the position of the printed matter on the page.
>
> [Morris, p. 1-2]

Nowhere is the elegance of Bible printing better represented in modern times than in the 1903 Doves Press edition printed by T. J. Cobden-Sanderson and Emery Walker (cat. no. 63). Produced in five volumes with red and black initials, its text is based upon the 1611 King James version, and was edited by Rev. F. H. Scrivener. Walker had worked with Morris at the Kelmscott Press and formed a partnership with Cobden-Sanderson in 1900.

The typographic style established by Messrs. Morris, Walker, and Cobden-Sanderson at the Kelmscott and Doves presses set standards for other fine printings of the Bible in the twentieth century. In 1910, C. W. Dyson Perrins had the Chiswick Press print sixty copies of a facsimile edition of the 1495 Italian edition of *Epistole et evangelii* . . . in his library for members of the Roxburghe Club (cat. no. 64). The work contained an introduction by Alfred W. Pollard, who explained the sources for the 1495 edition and traced the woodcuts back to the 1490 Malermi Bible printed for Lucantonio Giunta.

Other printers produced new typography for earlier Bible editions. The Nonesuch Press in London issued an English version in 1925, "according to the Authorized Version, 1611" (cat. no. 66), and the Anvil Press of Lexington, Kentucky, issued the Gospels in four volumes in 1954, based upon the Tyndale New Testament of the sixteenth century (cat. no. 70). Still others generated new translations altogether. The Cranach Press, for example, issued the Song of Solomon in German with wood engravings by Eric Gill in 1931 (cat. no. 67); concurrent editions were issued in Latin and English. C. H. St. John Hornby, an associate of William Morris and trustee of the Morris estate, issued in 1932 his edition of Ecclesiasticus, with hand colored initials by Graily Hewitt, Ida Henstock, and Helen Hinkley at the Ashendene Press (cat. no. 68). All of these modern efforts were founded on the same principles of the earlier printed editions: the spread of the Bible in print, with well printed, accurate texts.

This exhibition would not be complete without mention of the influence of the Bible upon children and their education, an aspect of Bible printing overlooked for the most part in previous exhibitions, but one which has particular interest at UCLA. The strength of the UCLA Children's Book Collection lies in its English books, especially those of the eighteenth and

nineteenth centuries when prescriptive instructional methods dominated the education of children. We offer two examples of the practice put into print, with the Bible as the text for the instruction. For the purpose of learning to read, Thomas Hodgson printed *A Curious Hieroglyphick Bible; or, Select Passages in the Old and New Testaments, Represented with Emblematic Figures, for the Amusement of Youth* (cat. no. 53). The use of emblems for story telling was a printing method developed in the sixteenth century. This example is actually a rebus, by which the sounding of the images' phonetics would suggest the Bible passage. In 1788, the same year of Hodgson's sixth London edition of this work, Isaiah Thomas produced in Worcester, Massachusetts, if not a piracy of this edition, then a remarkably close copy (cat. no. 54).

Portions of Scripture, for the Use of Children; to be Read as Lessons, or Committed to Memory, published in London by John Marshall around 1790 (cat. no. 55) comes closer to the prescriptive use of the day. It was a work compiled by Anne Bayley for the instruction of her grandchildren, and it is a typical example of the use to which the Bible was put in primary education during the late eighteenth century.

"The Printed Word" only hints at the range of editions of the Bible which have been produced since Gutenberg. The public, academic, and research institutions of Los Angeles – the city and county public libraries, the University of Southern California, the California State Universities, Loyola Marymount University, the University of Judaism, the Claremont Colleges, Occidental College, the Huntington Library, and the J. Paul Getty Center for the History of Art and the Humanities and the J. Paul Getty Museum – all have representative Bible collections, as John Bidwell has so admirably acknowledged in his introduction to this catalog. Our purpose in presenting "The Printed Word" at UCLA as part of *A Thousand Years of the*

Bible was to continue the theme showing how the Bible has proliferated throughout the world from the time of the invention of movable type printing. We look upon our exhibitions at UCLA as samplings of more comprehensive collections awaiting the research use of our readers. It is our hope that the installations here and at the J. Paul Getty Museum, which together comprise *A Thousand Years of the Bible*, will help scholars, students, and other visitors to recognize the significant resources available in Los Angeles for the study of the Bible, one of the greatest monuments in Western culture.

THE PRINTED WORD:
DEPARTMENT OF SPECIAL COLLECTIONS
UCLA RESEARCH LIBRARY

James Davis

Rare Books Librarian

Special Collections, UCLA

21. Bible. Latin. Vulgate. 1455.
 Biblia Latina. Mainz: Johann Gutenberg & Johann Fust, 1455.

22. Bible. Latin. Vulgate. 1471.
 Biblia Latina. Rome: Konrad Sweynheym & Arnold Pannartz, 1471.

23. Bible. Latin. Vulgate. 1475.
 Biblia Latina. Venice: Franz Renner & Nikolaus von Frankfurt, 1475.

24. Bible. Latin. Vulgate. 1476.
 Biblia Latina. Venice: Nicolas Jenson, 1476.

25. Bible. Latin. Vulgate. 1498.
 Biblia cum tabula nuper impressa & cum summariis noviter editis. Venice: Simon Bevilacqua, 1498.

26. Bible. Old Testament. Psalms. Polyglot. 1516.
 Psalterium, Hebraeum, Graecum, Arabicum, & Chaldaeum, cum tribus Latinis interpretationibus & glossis. Genoa: Pietro Paolo Porro, 1516.

27. Bible. Greek. 1518.
 Panta ta kat' exochen kaloumena Biblia theias delade Graphes Palaias te, kai Neas. Sacrae Scripturae veteris, novae'que omnia. Venice: Aldo Manuzio & Andrea Torresano, 1518.

28. Bible. Old Testament. Psalms. Polyglot. 1518.
 Psalterum in quatuor linguis: Hebraea, Graeca, Chaldaea, Latina. Cologne, 1518.

79

29. Bible. Latin. Vulgate. 1528.
 Biblia. Paris: Robert Estienne, 1528.

30. Bible. New Testament. Epistles & Revelations. Latin. 1537.
 Pauli Apostoli epistolae. Epistolae catholicae. Apocalypsis Beati Ioannis. Brescia: Damiano & Giacomo Filippo Turlino, 1537.

31. Bible. Old Testament. Hebrew. 1546.
 Arba' ye-ᶜésrim ... ha-ḥumash ... yeha-Nevi'im ha-rishonim ... yeha-Nevi'im ha-aharonim ... yeha-Ketuvim.... 4v. Venice: Daniel van Bomberghen, 1546-48.

32. Bible. New Testament. English. Tyndale. 1549.
 The Newe Testament in Englyshe and in Latin of Erasmus translacion. London: Wyllyam Powell, 1549.

33. Bible. New Testament. Spanish. Perez de Pineda. 1556.
 El Testamento Nuevo de Nuestro Senor y Salvador Iesu Christo.... Venice: Juan Philadelpho [i.e. Geneva: Jean Crispin], 1556.

34. Bible. English. Bishops' version. 1568.
 The Holie Bible, conteynyng the Olde Testament and the Newe. London: Richard Jugge, 1568.

35. Bible. Polyglot. 1571-1573.
 Biblia sacra, Hebraice, Chaldaice, Graece, & Latine. 8v. Antwerp: Christopher Plantin, 1571-73.

36. Bible. English. Geneva. 1589.
 The Bible. Translated according to the Ebrew and Greeke.... London: By the Deputies of Christopher Barker, 1589.

37. Bible. Dutch. 1590.
Biblia. Dat is, de gantsche H. Schrift.... Delft: Bruyn Harmansz Schinckel, 1590.

38. Bible. Latin. Vulgate. 1590.
Biblia sacra vulgatae editionis tribus tomis distincta. Rome: Ex typographia Apostolica Vaticana [Aldo Manuzio, the Younger], 1590.

39. Bible. New Testament. Gospels. Arabic. 1591.
Evangelium sanctum Domini Nostri Iesu Christi conscriptum a quatuor Evangelistis sanctis idest, Matthaeo, Marco, Luca, et Iohanne. Rome: In Typographia Medicea, 1591.

40. Bible. Latin. Vulgate. 1592.
Biblia sacra vulgatae editionis. Rome: Ex Typographia Apostolica Vaticana [Aldo Manuzio, the Younger], 1592.

41. Bible. Polyglot. 1596.
Biblia Sacra: Graece, Latine & Germanice.... 7pts. Hamburg: Jakob Lucius, the Younger, 1596.

42. Bible. Hungarian. Káldi. 1626.
Szent Biblia. Vienna: Formika Máte, 1626.

43. Bible. New Testament. Romanian. 1648.
Noul Testament.... Alba Iulia: A marii sale tipografie [Popa Dobre], 1648.

44. Bible. English. Selections. 1693.
Verbum sempiternum. London: Printed by F. Collins for T. Ilive, 1693.

45. Bible. English. Shorthand. 1696.
Holy Bible, containing the Old and New Testaments with singing Psalms in shorthand written by William Addy. London: Sold by I. Lawrence, ca. 1696.

46. Bible. Old Testament. Psalms. Ethiopic. 1701.
Psalterium Davidis Aethiopice. Frankfurt: J. D. Zunner & N. W. Helwig, 1701.

47. Bible. New Testament. Matthew VI, 9-13. Polyglot. 1715.
Oratio Dominica in diversas omnium fere gentium linguas versa et propriis cuiusque linguae characteribus espressa.... Amsterdam: David & William Goeree, 1715.

48. Bible. New Testament. Gospels. Church Slavonic. 1717.
Evangelie Iisusa Khrista: Vo slavlu cheloviekoiubtsa edinago triypostavnago Boga, Ottsa i Syna i Svetago Dukha. Moscow: V typ. tsarstvuiushtago velikago grada Moskvy, 1717.

49. Bible. Armenian. 1733.
Astuatsashunch: Girk Hnots ew Norots Ktakaranats.... Venice: Antonio Portoli, 1733.

50. Bible. English. Selections. 1757.
The Holy Bible abridged: or, The history of the Old and New Testaments. Illustrated with notes, and adorned with cuts. For the use of children. London: Printed for J. Newbery, 1757.

51. Bible. English. Authorized. 1769.
The Holy Bible, containing the Old Testament and the New; with the Apocrypha. Birmingham, Warwickshire: John Baskerville, 1769.

52. Bible. Welsh. 1770.

Y Bibl Sanctaidd: sef, Yr Hen Destament a'r Newydd, gyd a nodau a sylwiadau ar bob pennod. Carmarthen: Argraffwyd dros y parchedig P. Williams, gan I. Ross, 1770.

53. Bible. English. Selections. 1788.

A curious hieroglyphick Bible; or, Select passages in the Old and New Testaments, represented with emblematical figures, for the amusement of youth.... 6th ed. London: Printed for T. Hodgson, 1788.

54. Bible. English. Selections. 1788.

A curious hieroglyphick Bible; or, Select passages in the Old and New Testaments, represented with emblematical figures for the amusement of youth.... Worcester, Mass.: Printed by Isaiah Thomas, 1788.

55. Bible. English. Selections. 1790?

Portions of scripture, for the use of children; to be read as lessons, or committed to memory.... Compiled by a lady. London: John Marshall, ca. 1790.

56. Bible. New Testament. French. Le Maistre. 1804.

Nouveau Testament de Notre Seigneur Jesus-Christ, traduit en français par M. Le Maistre de Saci. Nouvelle edition.... 3v. Paris: Chez Gay; Chez Ponce; Chez Belin, an XIII [1804/05].

57. Bible. New Testament. Matthew VI, 9-13. Polyglot. 1806.

Oratio Dominica in CLV. linguas versa et exoticis characteribus plerumque expressa. Parma: Giovanni Battista Bodoni, 1806.

58. Bible. Old Testament. Apocrypha. Ecclesiasticus. English. Selections. 1807.
Moral maxims, from the wisdom of Jesus, the Son of Sirach, or Ecclesiasticus. Selected by a lady. London: Printed for J. Harris, 1807.

59. Bible. New Testament. German. Luther. 1827.
Das Neue Testament unsers Herrn und Heilandes Jesu Christi. Nach der deutschen Uebersetzung von Dr. Martin Luther. 8. ed. Carlisle, Pa.: Moser und Peters, 1827.

60. Bible. New Testament. Greek. 1828.
Novum Testamentum Graecum. London: William Pickering, 1828.

61. Bible. New Testament. Matthew VI, 9-13. Polyglot. 1860.
Coleccion polidómica mexicana que contiene la Oracion Dominical vertida en cincuenta y dos idiomas indígenos de aquella republica.... México: Libreria de Eugenio Maillefert y comp., 1860.

62. Bible. English. 1877.
The Holy Bible, containing the Old and New Testaments.... Oxford: Printed at the University Press; London, New York: Henry Frowde, 1877.

63. Bible. English. Authorized. 1903.
The English Bible. 5v. Hammersmith: The Doves Press, 1903.

64. Bible. New Testament. Epistles and Gospels, Liturgical. Italian. 1910.
Epistole et Evangelii et Lectioni volgari in lingua Toscana. The woodcuts of the Florentine edition of July 1495 reproduced in facsimile with the text from a copy in the library of C. W. Dyson Perrins. With tables and introduction by Alfred W. Pollard. London: Privately printed for presentation to the members of the Roxburghe Club, 1910.

65. Bible. New Testament. Spanish. 1917.
El Nuevo Testamento de Nuestro Señor Jesu-Cristo. Los Angeles: Casa Bíblica de Los Ángeles, 1917.

66. Bible. English. Authorized. 1925.
The Holy Bible, reprinted according to the Authorized Version, 1611. 4v. London: The Nonesuch Press; New York: The Dial Press, 1925-27.

67. Bible. Old Testament. Song of Solomon. German. 1931.
Das hohe Lied Salomo. Weimar: Cranach Presse, 1931.

68. Bible. Old Testament. Apocrypha. Ecclesiasticus. English. Power. 1932.
The wisdom of Jesus, the son of Sirach: Commonly called Ecclesiasticus. Chelsea: Ashendene Press, 1932.

69. Bible. Old Testament. Genesis I-VIII. English. Authorized. 1948.
The Creation: The first eight chapters of Genesis. Woodcuts by Frans Masereel. New York: Pantheon Books, 1948.

70. Bible. New Testament. John. English. Tyndale. 1954.
The Newe Testamente M.C.XXVI. The Gospell of S. Jhon. Lexington, Ky.: Anvil Press, 1954.

71. Bible. New Testament. Luke. English. Phillips. 1956.
 St. Luke's life of Christ. Translated into modern English by
 J. B. Phillips, with illustrations by Edward Ardizzone. Lon-
 don: Collins, 1956.

72. Bible. English. Authorized. 1963?
 The smallest Bible in the world. Dayton, Ohio: National Cash
 Register Co., 1964.

73. Bible. Old Testament. Exodus XX, 3-17. English. 1965.
 The Ten Commandments. Los Angeles: Bela Blau, 1965.

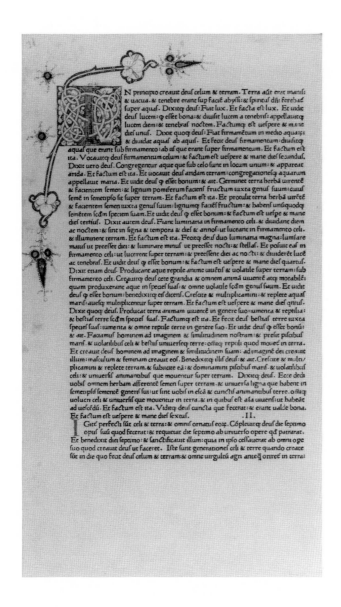

22. Bible. Latin. Vulgate. 1471.
Biblia Latina. Rome: Konrad Sweynheym & Arnold Pannartz, 1471.

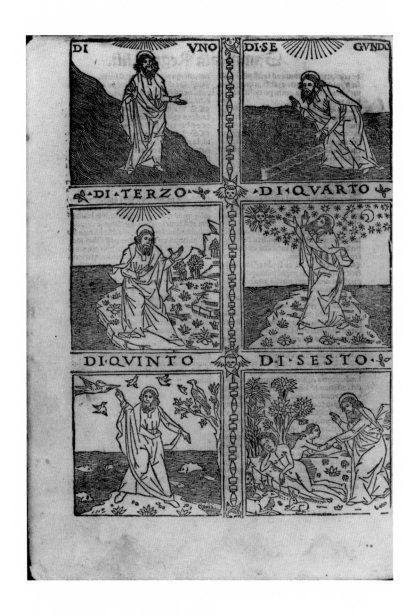

25. Bible. Latin. Vulgate. 1498.
Biblia cum tabula nuper impressa & cum summariis noviter editis. Venice: Simon Bevilacqua, 1498.

& semini eius vſ{que} in eternum.

XIX. In laudem.

Laudatoria Dauidis.

Qui ſuſpiciunt celos enarrant

gloriam DEI, & opera manuum eius

annunciant qui ſuſpiciunt in aera.

Dies diei apponit, & manifeſtat

verbum & nox noti

diminuit & nunciat ſcientiam.

Nõ eſt verbũ lamentationis, & nõ ſunt

ſermones tumultus & non

audiuntur voces eorum. In omnem

terram extenſi ſunt effectus eorum,

& in fines orbis omnia verba eorum,

ſoli poſuit tabernaculum,

illumiationẽ aũt í illos. Et ipſe ĩ mane

tanğ ſponſus procedẽs de thalamo ſuo

pulcherrime, & dum dſuiditur dies

letatur vt gigas, & obſeruat

ad currendam in fortitudine viam

occaſus veſptini. Ab extremitatibus

celorum egteſſus eius,

C. In omnem terram
exiuit filum ſiue litea
eorũ .eo intellectu quo
linea ꝑprie ſignificat
filum illud, quo mate-
riarũ utũtur fabricã
ſignandam materiam,
perinde ac ſi dixiſſet
propheta. exiuit ſtru-
ctura ſine edificiũ eo-
rum.

D. Et in fines mundi
uerba eorum, Saltem
tẽporibus noſtris qbo
mirabili auſu Chriſto
phori columbi genu-
enſis, alter pene orbis
repertus eſt chriſtia-
norũ q{ue} cetui aggre-
gatus. At ueroquoni-
ãm Columbus freqũe-
ter ꝑdicabat ſe a Deo
electum ut peripſum
adimpleretur heepro
phetia. non alienũ exi
ſtimaui uitam ipſius
hoc loco inſerere. Igi-
tur Chriſtophorus co
gnomento columbus
patria genuenſis, utli-
bus ortus parentibus,
noſtra etate fuit qui
ſua induſtria, plus ter
rarum & pellagi ex-
plorauerit paucis mẽ
ſibus, quam pene reli
qui omnes mortales
uniuerſis retro actis
ſeculis. Mira res, ĩ{que} ta

27. Bible. Greek. 1518.

Panta ta kat' exochen kaloumena Biblia theias delade Graphes Palaias te, kai Neas. Sacrae Scripturae veteris, novae'que omnia. Venice: Aldo Manuzio & Andrea Torresano, 1518.

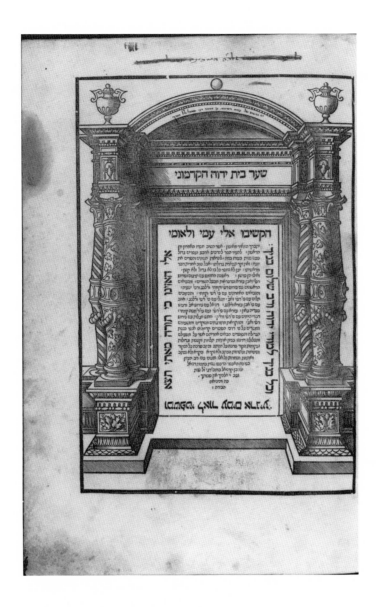

31. Bible. Old Testament. Hebrew. 1546.
 Arba' ye-ᶜésrim ... ha-ḥumash ... yeha-Nevi'im ha-rishonim
 ... yeha-Nevi'im ha-aḥaronim ... yeha-Ketuvim.... 4v. Venice:
 Daniel van Bomberghen, 1546-48.

34. Bible. English. Bishops' version. 1568.
 The Holie Bible, conteynyng the Olde Testament and the Newe. London: Richard Jugge, 1568.

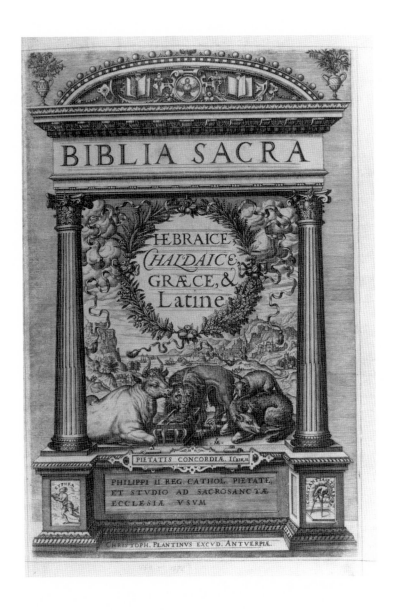

35. Bible. Polyglot. 1571-1573.

 Biblia sacra, Hebraice, Chaldaice, Graece, & Latine. 8v.
 Antwerp: Christopher Plantin, 1571-73.

LIBER IVDITH.

CAPVT PRIMVM.

 RPHAXAD itaque, rex Medorum, subiugauerat multas gentes imperio suo, & ipse ædificauit ciuitaté potentissimam, quam appellauit Ecbatanis, ex lapidibus quadratis & sectis: fecit muros eius in altitudinem cubitorum septuaginta, & in latitudinem cubitorum triginta, turres vero eius posuit in altitudinem cubitorum centum. Per quadrum vero earum latus vtrumque vicenorum pedum spatio tendebatur, posuitq. portas eius in altitudinem turrium: & gloriabatur quasi potens in potentia exercitus sui, & in gloria quadrigarum suarum. Anno igitur duodecimo regni sui: Nabuchodonosor rex Assyriorum, qui regnabat in Niniue ciuitate magna, pugnauit contra Arphaxad, & obtinuit eum in campo magno,

CAP. II.

Anno tertiodecimo Nabuchodonosor regis, vigesima & secunda die mensis primi, factum est verbum in domo Nabuchodonosor regis Assyriorum vt defenderet se. Vocauitq. omnes maiores natu, omnesq. duces, & bellatores suos, & habuit cum eis mysterium consilij sui: & dixit. cogitationem suam in eo esse, vt omnem terrá suo subiugaret imperio. Quod dictum cum placuisset omnibus, vocauit Nabuchodonosor rex Holofernem principem militiæ suæ, & dixit ei: Egredere aduersus omne regnum Occidentis, & contra eos præcipue, qui contempserunt imperium meum: Non parcet oculus tuus vlli regno, omnemq. vrbem munitá subiugabis mihi. Tunc Holofernes vocauit duces, & ma...

38. Bible. Latin. Vulgate. 1590.

Biblia sacra vulgatae editionis tribus tomis distincta. Rome: Ex typographia Apostolica Vaticana [Aldo Manuzio, the Younger], 1590.

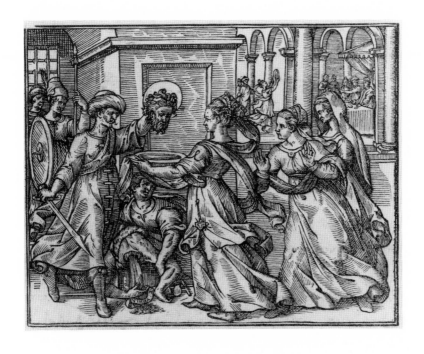

39. Bible. New Testament. Gospels. Arabic. 1591.

Evangelium sanctum Domini Nostri Iesu Christi conscriptum a quatuor Evangelistis sanctis idest, Matthaeo, Marco, Luca, et Iohanne. Rome: In Typographia Medicea, 1591.

LIBER IVDITH

CAPVT PRIMVM.

A RPHAXAD itaque, rex Medorum, ſubiugauerat multas gentes imperio ſuo, & ipſe ædificauit ciuitatem potentiſſimam , quam appellauit Ecbatanis,*ex lapidibus quadratis & ſectis : fecit muros eius in latitudinem cubitorum ſeptuaginta, & in altitudinem cubitorum triginta, turres vero eius poſuit in altitudinem cubitorum centum . * Per quadrum vero earum latus vtrumque vicenorum pedum ſpatio tendebatur, poſuitq. portas eius in altitudinem turrium:*& gloriabatur quaſi potens in potentia exercitus ſui,& in gloria quadrigarum ſuarum.*Anno igitur duodecimo regni ſui: Nabuchodonoſor rex Aſſyriorum , qui regnabat in Niniue ciuitate magna , pugnauit contra Arphaxad,& obtinuit eum*in campo ma-

CAP. II.

A NNO tertiodecimo Nabuchodono ſor regis,vigeſima & ſecunda die me ſis primi, factum eſt verbum in domo N buchodonoſor regis Aſſyriorum vt defen deret ſe.*Vocauitq. omnes maiores natu omneſq. duces,& bellatores ſuos,&habui cum eis myſterium conſilij ſui :*dixin cogitationem ſuam in eo eſſe, vt omnem terram ſuo ſubiugaret imperio.*Quoddi ctum cum placuiſſet omnibus, vocauit N buchodonoſor rex Holofernem principen militiæ ſuæ,*& dixit ei:Egredere aduerſu omne regnum Occidentis , & contra eos præcipue , qui contempſerunt imperium meū :*Non parcet oculus tuus vlli regno omnemq. vrbem munitam ſubiugabis mi hi.*TuncHolofernes vocauit duces,&ma

40. Bible. Latin. Vulgate. 1592.
Biblia sacra vulgatae editionis. Rome: Ex Typographia Apostolica Vaticana [Aldo Manuzio, the Younger], 1592.

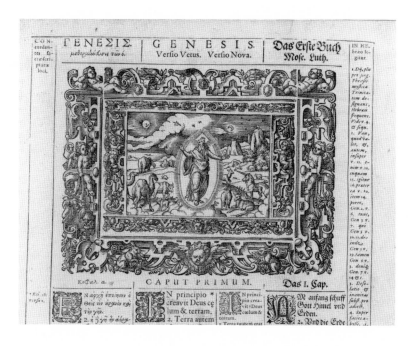

41. Bible. Polyglot. 1596.
 Biblia Sacra: Graece, Latine & Germanice.... 7pts. Hamburg:
 Jakob Lucius, the Younger, 1596.

43. Bible. New Testament. Romanian. 1648.
Noul Testament.... Alba Iulia: A marii sale tipografie [Popa Dobre], 1648.

48. Bible. New Testament. Gospels. Church Slavonic. 1717.
*Evangelie Iisusa Khrista: Vo slavlu cheloviekoiubtsa edinago
triypostavnago Boga*, Ottsa i Syna i Svetago Dukha. Moscow:
V typ. tsarstvuiushtago velikago grada Moskvy, 1717.

49. Bible. Armenian. 1733.
 Astuatsashunch: Girk Hnots ew Norots Ktakaranats....
 Venice: Antonio Portoli, 1733.

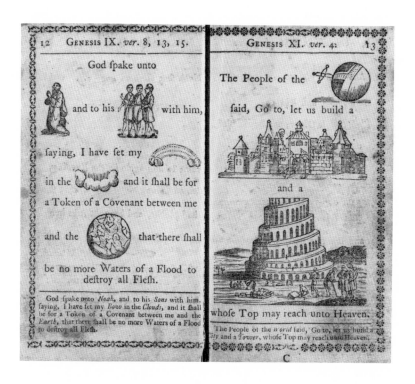

God fpake unto

and to his with him,

faying, I have fet my

in the and it fhall be for

a Token of a Covenant between me

and the that there fhall

be no more Waters of a Flood to
deftroy all Flefh.

God fpake unto *Noah*, and to his *Sons* with him, faying, I have fet my *Bow* in the *Clouds*, and it fhall be for a Token of a Covenant between me and the *Earth*, that there fhall be no more Waters of a Flood to deftroy all Flefh.

The People of the

faid, Go to, let us build a

and a

whofe Top may reach unto Heaven.

The People of the *world* faid, "Go to, let us build a *City* and a *Tower*, whofe Top may reach unto Heaven.

C

53. Bible. English. Selections. 1788.

*A curious hieroglyphick Bible; or, Select passages in the Old
and New Testaments, represented with emblematical figures,
for the amusement of youth....* 6th ed. London: Printed for
T. Hodgson, 1788.

Typesetting: *This catalogue was set in 11pt. Times Roman using Xerox Ventura Publisher.*
Cover, title pages and divider pages were set in ITC Galliard Roman.

Cover Design: *Robin Weisz*

Printing: *Alan Lithograph*

Project Coordination: *UCLA Publication Services Department*